Inking
ANIMALS

A modern, interactive
drawing guide to
traditional illustration
techniques

Sova Hůová

Brimming with creative inspiration, how-to projects, and useful information to enrich your everyday life, Quarto Knows is a favorite destination for those pursuing their interests and passions. Visit our site and dig deeper with our books into your area of interest: Quarto Creates, Quarto Cooks, Quarto Homes, Quarto Lives, Quarto Drives, Quarto Explores, Quarto Gifts, or Quarto Kids.

Walter Foster Publishing titles are also available at discount for retail, wholesale, promotional, and bulk purchase. For details, contact the Special Sales Manager by email at specialsales@quarto.com or by mail at The Quarto Group, Attn: Special Sales Manager, 401 Second Avenue North, Suite 310, Minneapolis, MN 55401 USA.

ISBN: 978-1-63322-576-3

Acquiring & Project Editor: Stephanie Carbajal
Page Layout: Melissa Gerber

Printed in China
10 9 8 7 6 5 4 3 2 1

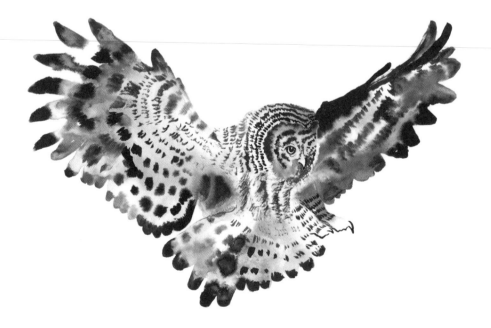

Table of Contents

Visit www.quartoknows.com/page/inking-animals to download the bonus material, including tips for working digitally, additional creative exercises, worksheets, and more!

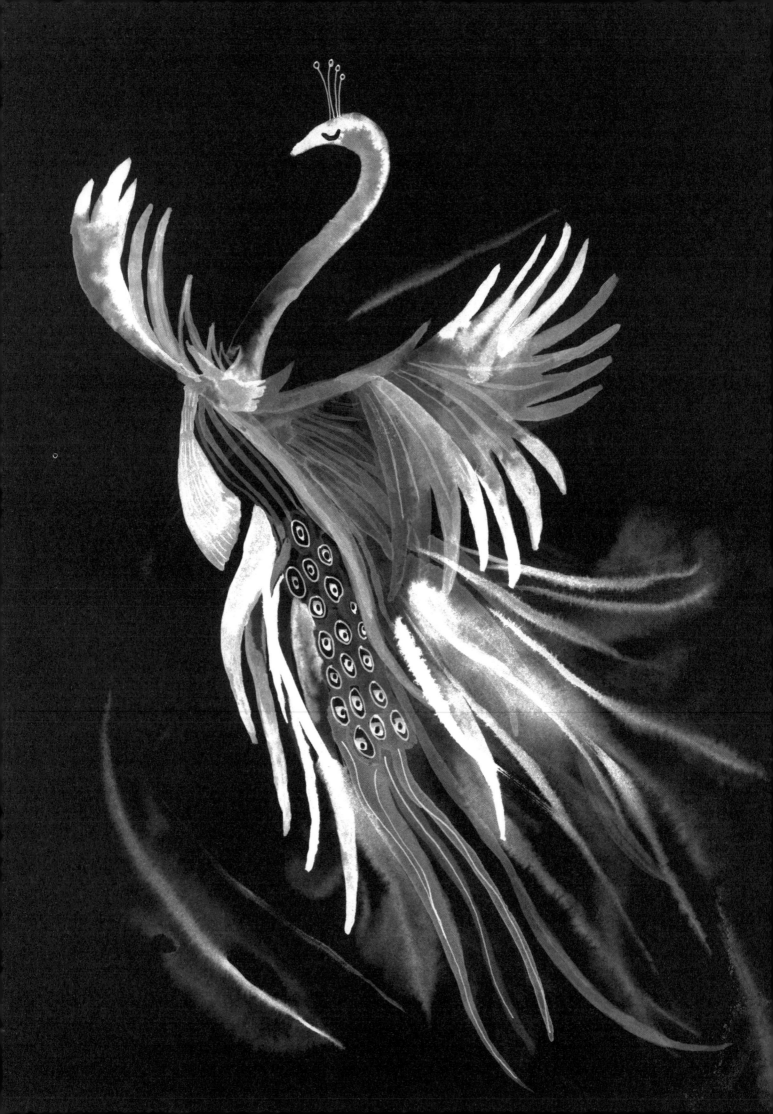

INTRODUCTION

My great-grandaunt used to arrange long, boring (for me, since I was a child) family lunches followed by lazy Sunday afternoons. We ate from antique plates and drank from crystal glasses, and the only "appropriate" thing for kids to do was play with uninteresting, ancient toys—or draw.

I drew a lot on these occasions, as you can imagine. One day I drew an elephant. I brought my drawing to the table to show the adults. "Wow, she has a gift—animals are so difficult to draw!" my great-grandaunt said, and everyone else agreed with her. "No, it's not," I thought to myself, because I'd never found it difficult. I drew a turtle, a Dalmatian, and a few other animals to prove the adults wrong, and they were amazed as I showed them drawing after drawing.

Of course, they were probably saying those things to make me happy, but I learned something important that day—something that's important for anyone reading this book: It's not difficult to draw animals. All you need to do if you want to draw them perfectly—whatever that means to you—is simply try again and again.

So, lay your fears aside. Feel free to experiment when completing the exercises in this book. You can express yourself any way you like, even if it's because you can "only" draw in that one particular way—there's absolutely nothing wrong with that!

Drawing used to scare me. I worried that I wasn't talented enough, which completely blocked the flow of my creativity for several years. In that period, I allowed myself to write only academic texts, which gave me safe boundaries to create within. Then I got pregnant—and suddenly I was free of those boundaries. That's when I got my first job as an illustrator, and I started teaching art classes for children. I created an art project every week, and there was no one to judge whether what I came up with was or wasn't a piece of "real" art. There was no one to tell me I had done something wrong or that I'd failed completely as an artist. After two years of teaching, learning, and working on my artistic skills, I realized I had become an artist.

This book should serve as a safe, supportive space in which to create and practice, which is exactly what most shy, artistic people need at the beginning of their journey.

I learned the techniques used in this book mostly from other artists, many of whom were self-taught, and I also developed some of the methods myself. I didn't go to a university for art, although I have studied it for many years in several ateliers. You may find my techniques a bit unorthodox. I hope you will also find them innovative and fun and that this book will encourage you to develop your own artistic style!

Tools & Materials

Inking materials are affordable and easily accessible. They are simple to work with and suitable for a variety of techniques. You may even have some of them at home already—and if you don't, you can find them at your nearest art-supply store or favorite online art-supply retailer.

Drawing Tools

Traditional Dip Pens Dip pens with replaceable nibs are probably the most popular tools for inking. The flexibility of the nib determines the line thickness it offers; many nibs even give your strokes some calligraphy effects. Unlike fountain pens, dip pens can be used with india ink and acrylic inks.

Fineliners You can purchase fineliner pens with either water-based or oil-based ink. They are available in a wide range of thicknesses (from 0.05 mm to 1 mm). I prefer waterproof pens with minor bleeding, which encompasses a wide selection ranging from micro-pigment pens designed for general drawing to specialized pens for drawing manga (usable with alcohol-based markers) or comics.

Water Brush Pens Water brush pens, often used for Chinese calligraphy, allow you to vary the line weight by the amount of pressure you apply. By adjusting the ink flow, you can also use them for dry textures. You can refill them either with ink or ink cartridges. I use brush pens that contain waterproof ink.

Calligraphy Brush Markers These markers have a flexible brush at the tip. They often come in a set of fineliners as an option to create variability in line thickness. Since they are easy to handle, they are commonly used for modern calligraphy.

White Gel Pen You can draw over dark designs and areas with a white gel pen. The opacity of this pen enables you to add fine details to your finished drawings.

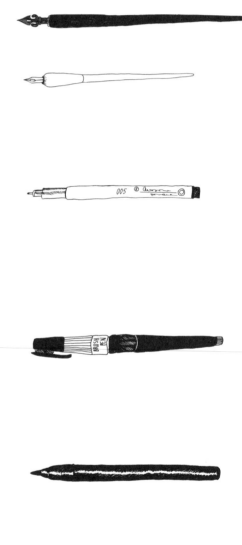

Watercolor Brushes Small watercolor brushes are essential tools for painting with ink and working wet-into-wet. My favorites are sizes 0 and 00 with natural sable hair. You can use synthetic brushes as well, though they're not as precise.

Mop Brush These tools with natural fibers are great for watercolors, as well as ink washes and wet techniques. You can use them for several styles, from calligraphy to precise ink paintings. Their ability to hold water is amazing.

Other Brushes While round watercolor brushes are the most popular and traditional for inking, there's nothing wrong with trying flat brushes or others (even a toothbrush!) to experiment and create texture in your artwork.

Pencils For sketching, I use mechanical pencils with HB or 2B refills. I use 2B for smoother papers—the lead is darker, and I enjoy working with them—and I use lighter HB or even 4H for textured watercolor paper to make erasing easier.

ARTIST'S TIP

If you work often with watercolors, purchase separate brushes for watercolor and inks. India ink changes the shape and quality of brushes and destroys them quicker. Wash your brushes with special soap for art supplies to avoid this.

Ink

India Ink Plenty of artwork in this book was created with india ink applied with different tools. You can find a wide selection of india ink, from very cheap to expensive. It is available as water-soluble or stable. Some india ink is safe to use even with alcohol-based markers, while some can be reactivated by the alcohol. Since I like to work in layers, I use waterproof ink.

Depending on the paper you use, ink can create lines ranging from very clear to blurry. Some inks are extra dark, while others are more grayish. Some have a matte finish and others are glossy. Drying time can vary as well. I recommend starting with something cheaper and seeing how it works for you.

Block Printing Ink Another handy ink to have on hand is block printing ink, which is applied with a roller or sponge. These inks are also available as oil-based or water-based, which is easier to work with and clean.

Water & Palette I use water and various palettes to work with different shades of diluted ink. I usually have at least two to three jars of water for inking, because it goes gray very quickly. Don't let your brushes stay in the water container for too long if you want to keep them in good shape.

Paper

Sketchbook Use a sketchbook you feel comfortable with. To make inking easier, I recommend using white paper so you can easily transfer your sketches to other papers. Ring notebooks are helpful, because you can easily place your design on a light box.

Printer Paper This is the most common affordable paper to use for sketching or drawing with fineliner pens. It's a great option for concept art.

Bristol Paper Bristol is a high-quality, extra-white paper with a characteristic smooth finish. For me personally, it's the best option for creating ink illustrations and wet ink effects.

Watercolor Paper Watercolor paper is a great option for wet ink effects and ink washes. I prefer hot-pressed paper with less texture, because I don't need to clean up the paper texture after scanning my artwork. You can begin with a watercolor wash and redraw it with liners, or start with waterproof liners and color your illustration with watercolors.

Bleedproof Paper for Markers A lightweight paper that does not bleed with liners or brush pens and is also great for alcohol-based markers.

Sumi-e Paper This rice paper is made for Japanese brush painting and calligraphy. It's absorbent and lightweight and creates feathering effects with ink and watercolors.

Printmaking Paper Heavyweight paper for printmaking is textured and absorbent and can also be used for various mixed-media techniques.

Additional Materials

White Gouache Paint Gouache is an excellent alternative to white gel pens. It's an opaque watercolor that you can paint over your artwork with. The opacity depends on the amount of water added to the paint. With a small watercolor brush, you can achieve very thin lines.

Soap I use a special soap for art tools that I bought at an art-supply store. Ideally, you should wash your brushes every time you work with ink.

Masking Fluid When you don't want to paint over your ink drawing with white, you can cover the area you wish to keep white with masking fluid, which is basically liquid rubber. Simply paint over it, and then remove the masking fluid when the paint is dry. I strongly recommend masking fluid with an applicator, but you can also get it in a bottle. If you choose to use it with your own brush, be sure to use an old one, as the masking fluid will destroy the bristles.

Light Box A light box allows you to easily trace your sketches or references on drawing paper. See pages 10 and 11 to learn how to make your own!

Rollers In this book, we'll use rollers to create texture for printmaking.

Color Media You can add color to ink drawings with watercolors, markers, colored pencils, or even digitally. Read more about coloring inked art in "Adding Color" on pages 24-25.

Graphics-Editing Software I use Adobe® Photoshop® to adjust my art after scanning by changing the colors, exposure, or light. I often remove or clean the background to create art prints. Sometimes I color the background with Photoshop's paint bucket tool.

Visit www.quartoknows.com/page/inking-animals to download the bonus content for this book and find tips on working digitally!

DIY Light Box

A light box lets you trace sketches you made on cheap paper without focusing much on the process of transferring, or you can try different color schemes on one design without spending hours redrawing. Light boxes are relatively affordable, but it's also easy to make one at home from materials you can get in any hobby shop.

What You Need

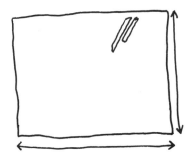

Glass slab (mine is approximately 12" x 16")

A canvas or wood frame the same size as the glass

Strip of LED lights

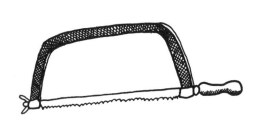

Handsaw

White paper

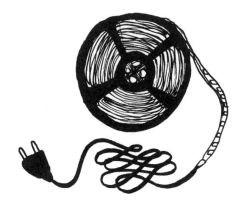

Universal glue for glass and wood

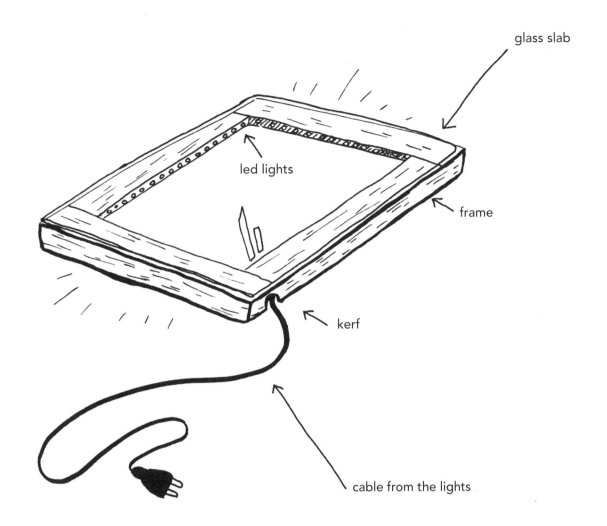

glass slab

led lights

frame

kerf

cable from the lights

Use a handsaw to make a slit, also called a "kerf," in the canvas or wood frame, deep enough to hold the power cord for the LED lights.

Glue the LED lights to the inside of your frame or canvas. If you have enough space for two rows of LED lights, even better! More light will provide better results. Trim the remainder of the LED light strip that doesn't fit in the frame.

Glue your glass slab to the top of the frame with the universal wood glue, and allow it to dry. Now your light box is ready to use!

USING A LIGHT BOX

Choose your best sketch and put it on your light box. Then select a new sheet of paper, based on your project, and place it over the original sketch. The lines are visible through the paper on top, and you can trace them freely.

Inking Basics

Different inking tools yield different results, yet the essential techniques and strokes remain the same. I highly recommend practicing with different tools to discover which ones suit your personal drawing style.

Start by creating straight lines with several tools. Drawing pens (liners) have very little thickness variability. The flexibility of traditional dip pens is small and depends on the nib. These tools allow you to be precise. Brush pens have fantastic variability, allowing you to create impressive textures, but they take more practice. My favorite inking tool is a small watercolor brush (size 0). I love its flexibility and the extra-thin line and precision it achieves in both dry and wet techniques.

Dip pen

Thin watercolor brush

Drawing pens

Big Japanese brush pen (with cartridge)

Medium brush pen

Thin brush pen

Techniques

Stippling

To stipple, make dots (or other shapes) next to one another. You can create shading by leaving less space between the dots for light areas and placing them closer together for dark areas. Depending on what tool you use, you can achieve extra-neat textures, messy, or even seemingly uncontrolled ones.

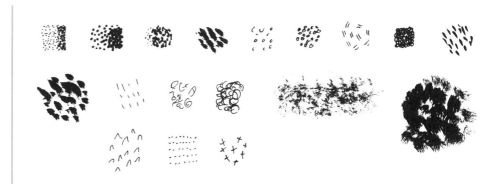

Hatching

To hatch, simply lay down parallel lines next to one another. Like stippling, you can create shading by varying the amount of space between the lines—more space for light areas, and less space for darker areas.

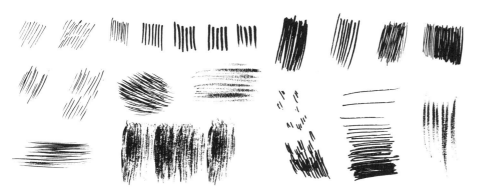

Crosshatching

Crosshatching is simply hatching, but you cross the lines.

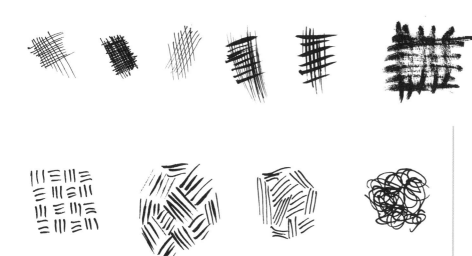

Other

These strokes form the base of all inking styles. You can combine them in many ways! Another common style is the "wandering line," in which your pen draws freely along the outline without a lot of planning.

Wet Techniques

I often use loose ink washes—they're my favorite. I start with water or a lighter shade and add india ink. I love how uncontrollable they are and the smoky effects they create. Even though the flow of india ink can be quite wild, you can learn to control a significant part of the results with some practice.

By mixing ink and water, you can create lighter gray shades.

 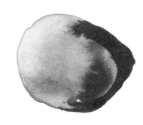

Dried ink from the previous day can create impressive results as well. This is what happens when you use old water with bits of ink.

Another popular technique is to splash the ink by fiercely tapping a brush with slightly firmer bristles.

It's not easy to control, so this technique can be used to add a messy finish to drawings. You can also splash with white ink to create stars or snow on a dark background.

Animal Patterns

You can combine techniques to create sophisticated animal patterns or furry textures.

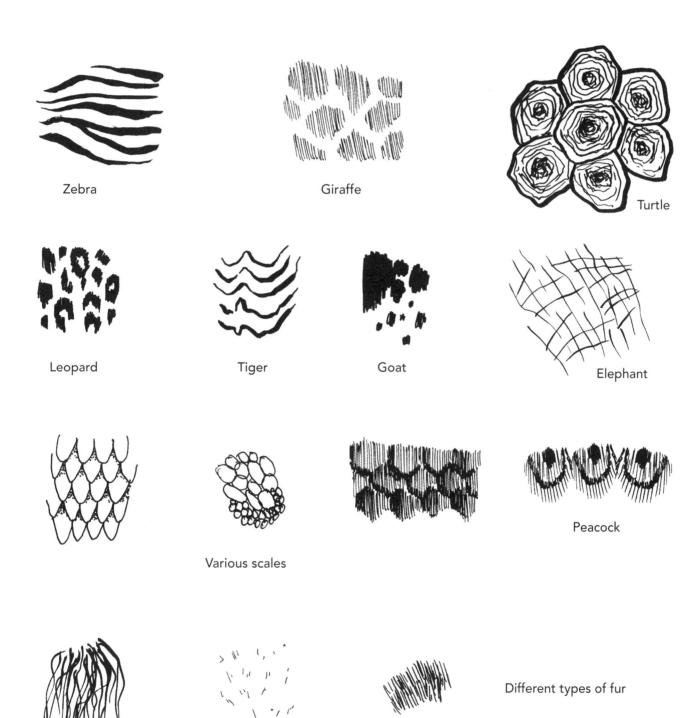

Zebra

Giraffe

Turtle

Leopard

Tiger

Goat

Elephant

Various scales

Peacock

Different types of fur

Finding Inspiration

Let's talk more generally about how artists find inspiration. Sometimes a good idea just comes to you in an unexpected place, whether you're sitting on a bus or taking a shower. You may be inspired by other people or perhaps a memory from your childhood.

FEAR OF THE BLANK PAGE

Sometimes, when you feel pressured, you can stare at a blank page for an hour and not come up with anything. Or you may have a stunning idea that is so intimidating and valuable to you that you're afraid your drawing skills aren't good enough to express it.

This fear goes hand in hand with drawing, writing, and other creative activities. This book is here to help you conquer this fear. Feel free to doodle, experiment, and make mistakes and imperfections. These aren't failures—they're part of the process.

You don't have to fear making mistakes in your drawing. A good illustration is more about thinking of the concept, while drawing skills are only a matter of practice. My favorite thing to do when I feel pressured to start drawing is turn the page over and paint something on the reverse side. It often happens that it comes out even better than my original idea because the pressure is gone!

EXPERIENCE

My first piece of advice is simple: Head outdoors to the mountains or the park, or visit a farm or the zoo. Observe real animals and sketch them. If you have pets, make sketches of them! You can also take photographs for future reference.

Another thing you might try is making miniature comics of your everyday life, with either your pets or other people's pets. Draw simple pictures, and maybe add some text. Through this, you will learn to simplify and translate your reality into short funny stories.

PLAY

As you watch the world around you, try to view it like it's the first time. Let yourself play as if you were a kid again. Notice the designs on beetles' wings, the surface of stones, or different types of grass. If you meet kids that tell you interesting stories, allow yourself to draw things from their imaginations. Push yourself out of your comfort zone. Try new techniques—draw on pebbles, carve wood, make necklaces. You can learn a lot from this because it forces you to think differently.

There's a lot of pressure on us to be productive, to multitask, to have every minute of every day planned out and filled with exciting and important activities. But it's important to remember that the best ideas usually come when we simply do nothing, allow ourselves to slow down, or stop altogether. If you find yourself in a creative rut, I would definitely give this a try.

PINTEREST™

The ease and reach of the Internet and social media make it challenging to avoid being influenced by other artists and their work. It can be frustrating to think of something wonderfully original, and then go online and find that someone else has already done something similar. But don't let this discourage you! It's not necessarily a bad thing; you can take a different approach or style, or you may be inspired to come up with something even more original and truly yours.

I'm a huge fan of Pinterest. It's an invaluable tool for illustrators and all other kinds of creative people, because it lets you gather information about a topic and refine your ideas so that you can start creating something on your own. Just remember that it's useful to spend time offline as well. When was the last time you didn't check your inbox or spent a whole day off social media? When your mind isn't constantly filled with content created by other people, you'll realize that you are full of creative potential yourself.

JUST START

It may surprise you to know how many people struggle when it comes to putting newly learned skills into practice. Don't have india ink at home? Don't worry about it. Don't have the right kind of paper? Start anyway. Can't find the time? Fill in the exercises in this book while waiting for a bus. Don't put things off for a better time—just start.

Drawing Animals

I'm going to show you a simple way to draw animals that has nothing to do with the level of your artistic skill. I use this tool almost every time I draw. If you find you don't know how to start a new project, come back here and try some of these methods. While I drew some lifelike animals in this book, you'll notice that most are somewhat simplified and stylized. I usually use a combination of observing real-life references, photos, or videos, and then I finish the artwork with my own artistic shortcut. The following pages demonstrate how I do this process and include exercises to help you quickly draw almost anything. The primary goal is to deconstruct animals into simple shapes and pick out their most important features.

Process of Abstraction

Geometric Shapes

Find a photo reference and look at it closely. Do you see any geometric shapes? Limit the number of lines. Try to draw your animal almost as a geometric icon.

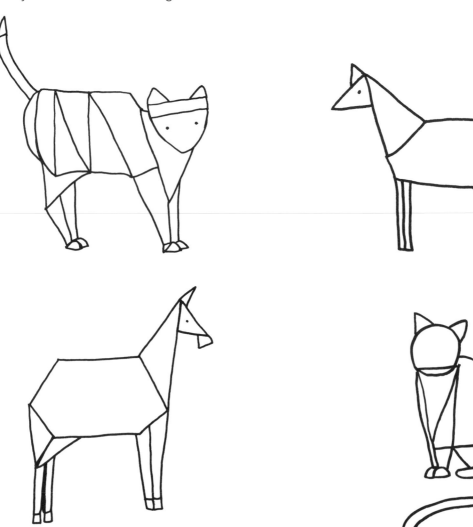

Organic Shapes

You don't have to limit yourself to narrow lines to sketch the base of an animal's shape. Draw any shapes you previously left out. Once you find these shapes, you can trace an organic silhouette.

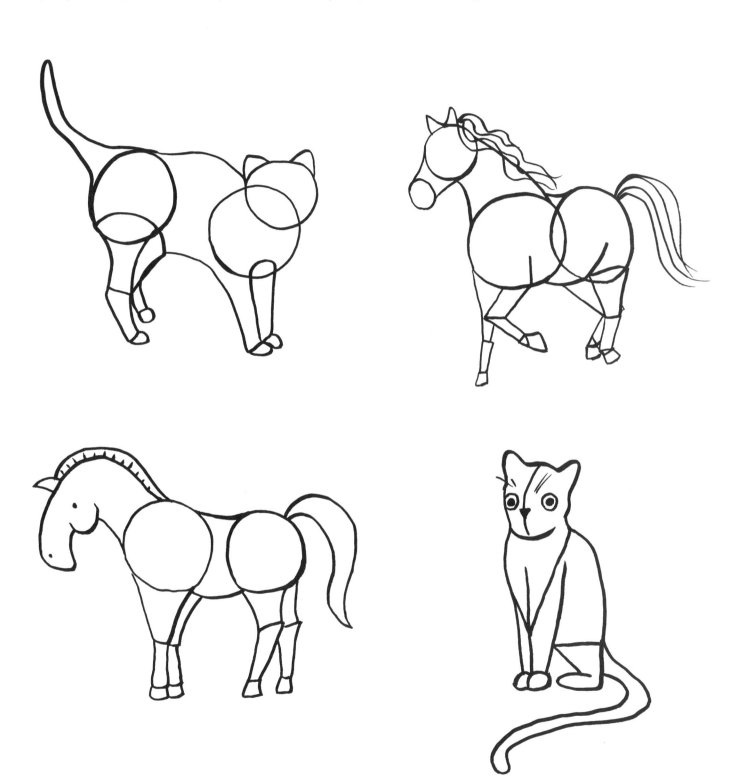

Silhouette

When you connect those shapes, you get a silhouette to which you can add more details. You can ink it in various ways, which we'll explore in the following tutorials.

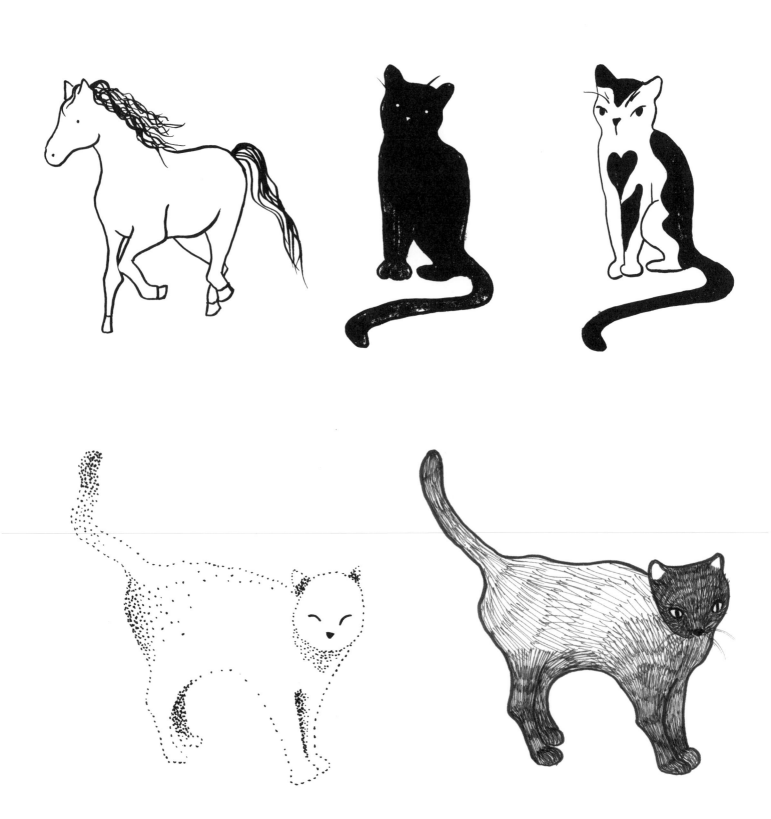

You can also play with the shapes and their ratios, or simplify them. Once you have a clearer idea of the main shapes of your animal, you can experiment and create your own shortcuts.

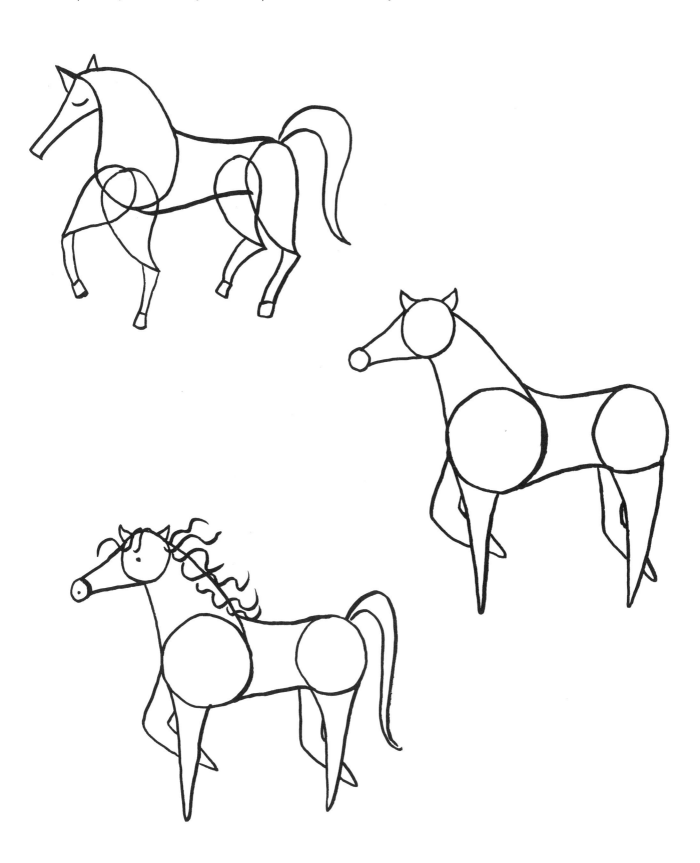

Adding Character

Once you have created a generally realistic silhouette, you're free to give your animal character by adding different eyes and a nose, playing with the ear shape, and experimenting with the sizes of all the features.

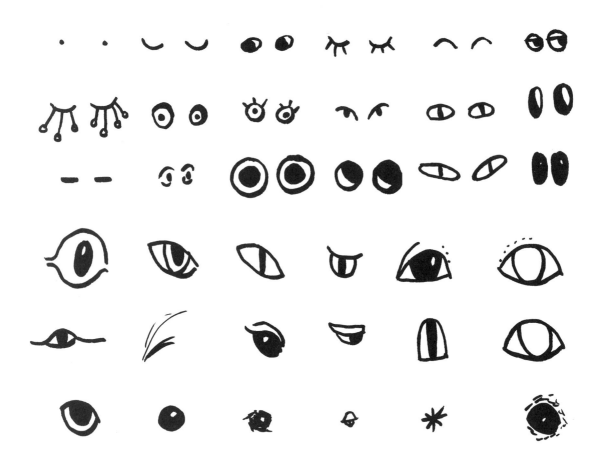

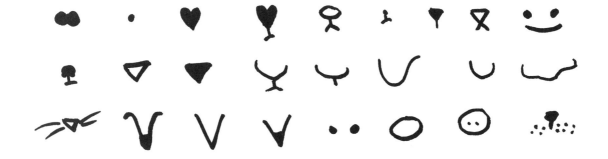

With this simple approach, you can create anything, from very naïve to quite realistic-looking animals. By playing with the eyes and noses, you can achieve many completely different impressions with just one animal silhouette.

EVEN SMALL DETAILS CAN CREATE A SIGNIFICANT DIFFERENCE IN THE MOOD OF YOUR PICTURE!

Adding Color

I love to work in monochromatic grayscale, but sometimes it's great to add color to an illustration to make it more dramatic or cheerful. So how do you go about combining ink and color?

Color Media

One of the most traditional ways to add color is to simply color in your design with the medium of your choice. In these examples, I combined a simple outline drawn with a waterproof fineliner with different media:

- Watercolor: Add color in only some areas of your design, or apply color to the whole thing. You can work in loose strokes or be very precise.
- Gouache: Similar to watercolors, the opacity of gouache can cover some of your linework. Consider diluting with water.
- Marker: Alcohol-based markers work especially well in tandem with ink.
- Colored Pencil: Although not as popular as watercolors in contemporary illustration, colored pencils can create fresh and playful art pieces. You can even use watercolor pencils, which let you create washes and build a mixture of watercolor and pencil texture.
- Digital: Touch up or add color digitally for a modern, clean feeling.

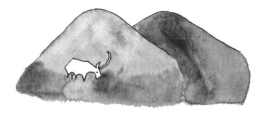

Watercolor

Watercolor Pencils

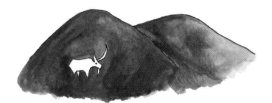

Gouache

Colored Pencils

Alcohol-Based Markers

Digital Coloring

24

Inking Over Other Media

There are different opinions on whether to use ink or paint first. I think there's no wrong choice. Both techniques can be used to achieve good results, so it's up to you which one to start with. For these trees, I started with watercolor and drew over them with a fineliner and a gel pen.

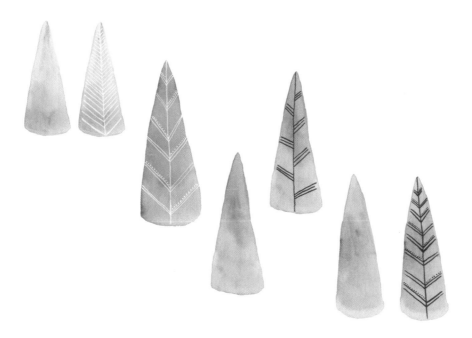

Combining Media

You can also blend ink with other media.
Here is what a wash of watercolor and ink looks like.

The opacity of gouache allows you to paint over dried ink layers,
so you can redo even the darkest parts of your artwork.

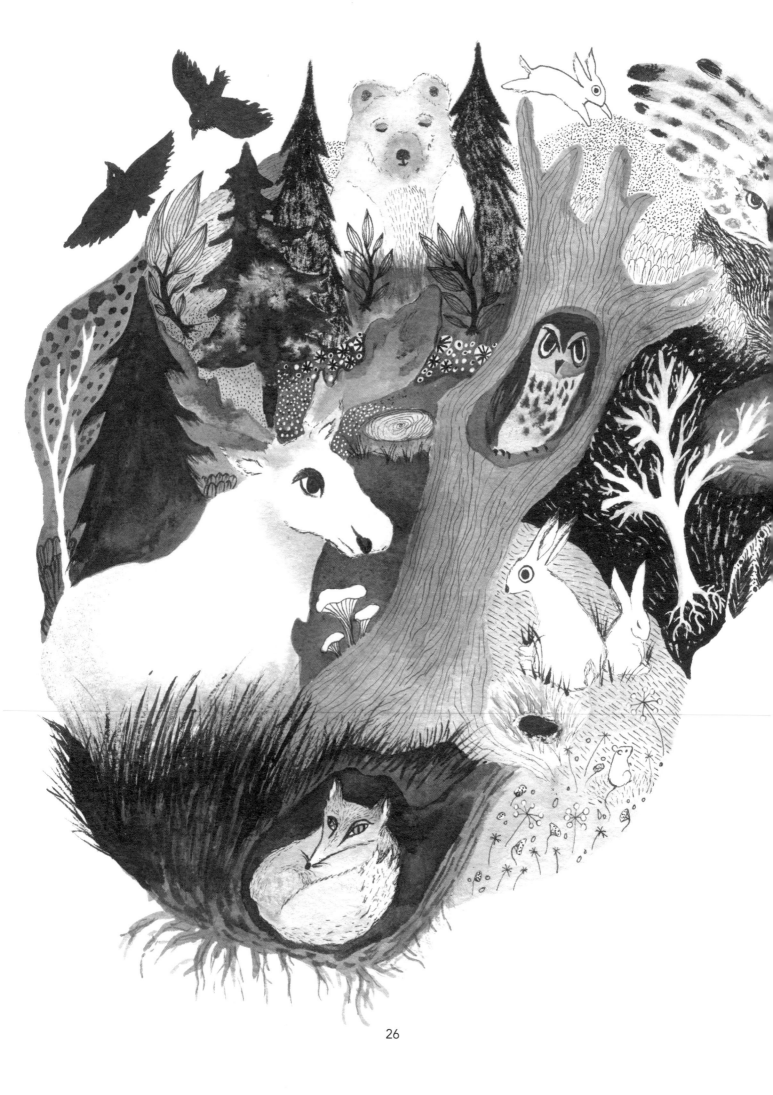

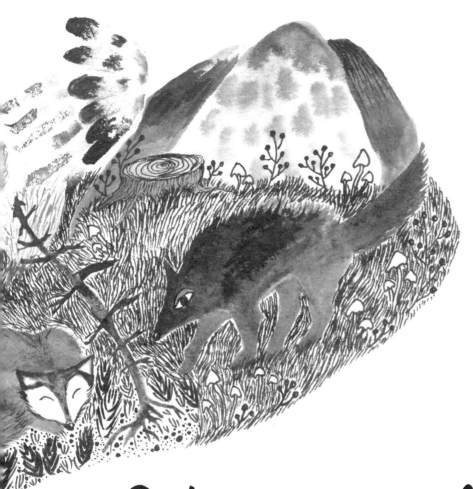

WOODLAND ANIMALS

Woodland animals are popular in the world of illustration! This section of the book will help you develop basic inking skills, while exploring how to draw and paint various woodland animals. We'll explore wet-into-wet painting, the practical uses of hatching and stippling, and how to work with different levels of opacity.

CAN YOU IDENTIFY THE TECHNIQUES AND TOOLS USED IN THIS ILLUSTRATION?

Techniques: Stippling, hatching, drybrushing, wet-into-wet painting
Tools & Materials: Drawing pens and watercolor brushes,
a white gel pen, a brush pen, india ink, and water on watercolor paper

BEAR: WET INKING

First, let's learn how to let ink magically flow and create beautiful effects in water for a wet inking technique. Bears are fierce and dangerous, but they are also loving and caring parents who enjoy playing with their cubs. It's nice to combine the strength of this animal with something soft and vulnerable, which is why I decorated the silhouette with simple floral elements.

A bear is a great animal for beginners—it's simple in shape,
yet the results can be impressive.

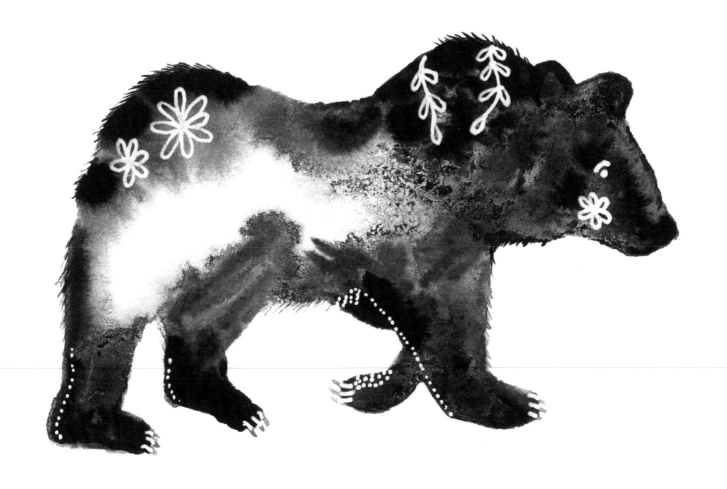

Materials

HB PENCIL
LIGHT BOX OR WINDOW
SMOOTH ILLUSTRATION
OR WATERCOLOR PAPER

INDIA INK
WATERCOLOR BRUSHES
WHITE GEL PEN

The Sketch

The bear's silhouette is easily reduced to simple shapes—mostly ovals and a rounded triangle. Follow a photo reference to draw the shapes in pencil. I always draw each shape two or three times and then choose the one that fits the final animal best. Create the outline of the animal around the shapes. I used a drawing pen, but you could also use soft pencil. It's important to keep the outline clear and visible.

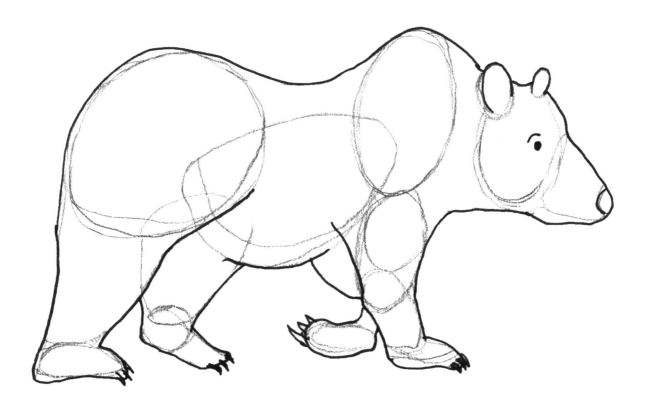

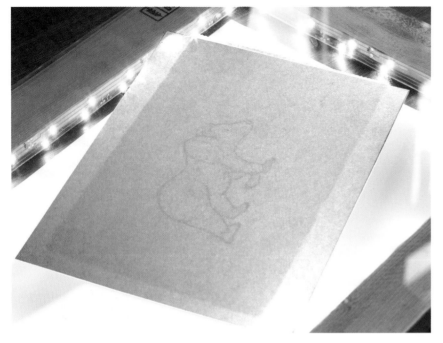

Using a Light Box

If you don't have a light box or a glass table that you can place a light beneath, use a window to copy the outline onto a new sheet of paper using thin, light pencil lines.

If you use a light box, there won't be pencil lines on the final illustration. Simply place the sketch on the glass and cover it with a clean, smooth sheet of illustration or watercolor paper. The outline will be visible through the paper.

Water

Use a watercolor brush to fill the silhouette with clean water. When the water starts to dry, add another layer. You need to apply enough water so that the silhouette stays wet for two to three minutes. If you're using drawing paper, check that it doesn't start to crumple with the wet application.

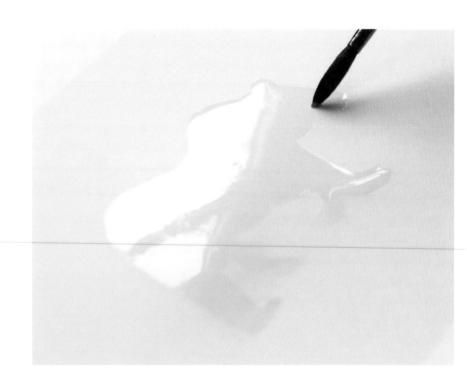

ARTIST'S TIP

It becomes easier to guess the right amount of water once you've had some practice, so keep at it!

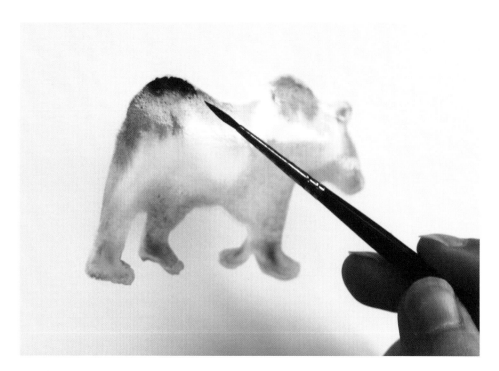

Ink Wash

This requires a moment of concentration. Once you dip your brush in the ink and mix it with water on the paper, you can't leave the painting for even a few moments, or you'll create sharp edges. I premix ink with water in a separate bowl and start adding this lighter shade of ink first. The ink flows and mixes with the water on the paper to create beautiful effects.

Touch the brush very lightly to the page to avoid applying too much ink. You can't control where the ink flows, but you can create shadows and darker spots by slowly and carefully adding darker layers of ink. Don't be afraid of the ink—the worst that can happen is that you add too much and the painting turns into a black or gray silhouette, which might create a beautiful final illustration!

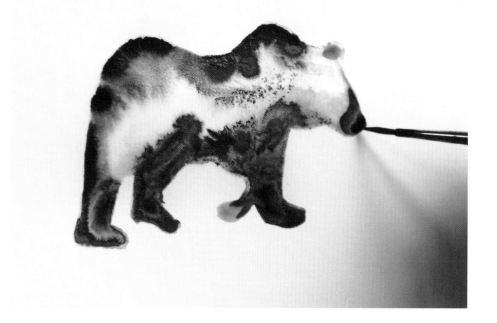

Brush Detail

Once the silhouette is done and starts to dry, try to catch the moment when the edges are still wet enough to add some details with a tiny watercolor brush. I paint the fur in some places and try to match the shade of my ink mixture with the part that it connects it to. I also paint the claws.

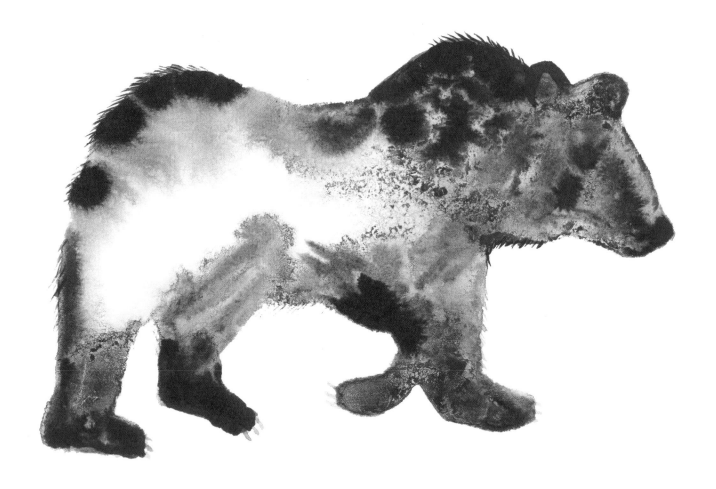

Finishing Touches

Once the ink is dry, use a white gel pen or a nib pen and white ink to draw the eye and add a few fun floral details. I also apply stippling to help define the legs. You could also add lettering or any other kind of embellishments.

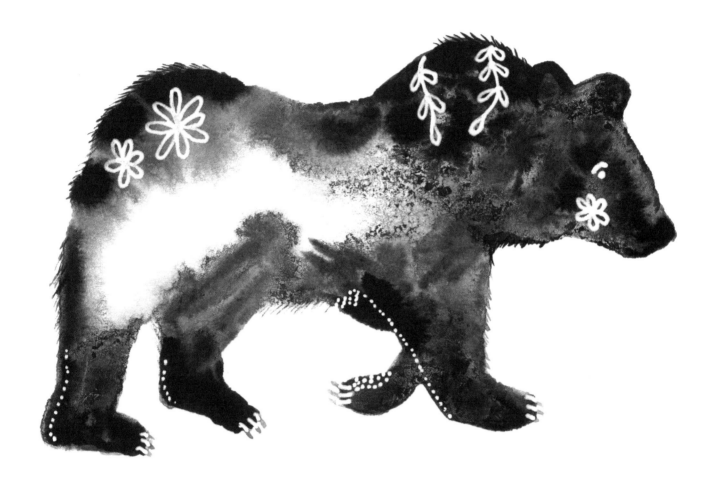

FOX: DRYBRUSHING

When I was little, I fell in love with an illustrated book that included a fable called *The Stork and the Fox* by Jean de La Fontaine. The fox in this story tricks the stork, who then tricks the fox. In this illustration, try to capture the human features that society usually attributes to a fox: intelligence, cleverness, and slyness.

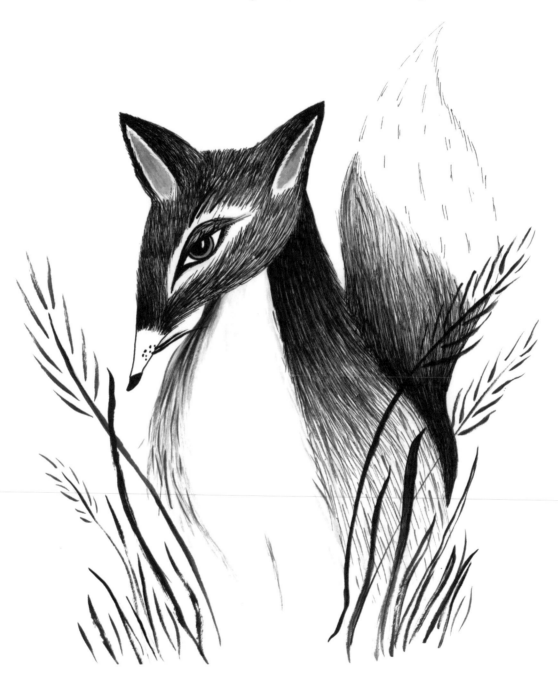

FOLKLORE TIDBIT

Even in the most ancient stories, foxes are depicted as clever and crafty. In Asian mythologies, the fox is a demon, who often looks like a beautiful woman. These shape-shifters are believed to have many magical powers. This fox may occasionally help people, but more often she acts as a malevolent spirit who causes trouble.

Concept Development

Study some photo references of foxes before beginning your first sketches. I like to work out my concept in a sketchbook, so I don't worry about ruining expensive paper. As you work on the initial sketch, think about what parts of the illustration will appear lighter and darker and what the environment will look like.

Test some loose brushstrokes with a few different brushes on a piece of the smooth illustration paper you'll use for the final illustration. Aside from practicing the brushstrokes you'll use later on, this step also shows you how the paper reacts with water and watercolor.

Materials

SMOOTH PAPER FOR ILLUSTRATION (BRISTOL, 250 G/M²)
WATERPROOF DRAWING PENS (0.05 MM, 0.3 MM)
WATERCOLOR BRUSH (NO. 0)

ORANGE WATERCOLOR

HB PENCIL

INDIA INK

Sketch

Once you're happy with the concept, redraw the sketch on illustration paper using a light box or sunny window. Keep all the lines very light and thin so they won't be visible in the final drawing. It's better to allow for loose strokes in your inking—the drawing will look more spontaneous.

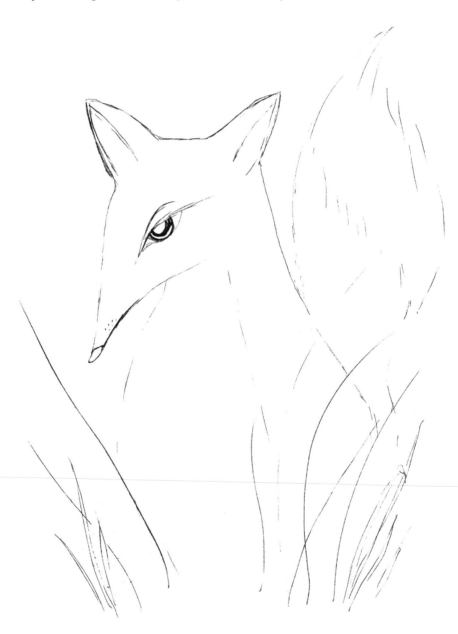

Inking with Pen

Ink the eye first—it's the most detailed part. Then create an initial light layer of fur using a thin drawing pen. Make your strokes in the same manner as in the concept sketches, keeping it light with thin strokes to create the effect of fur.

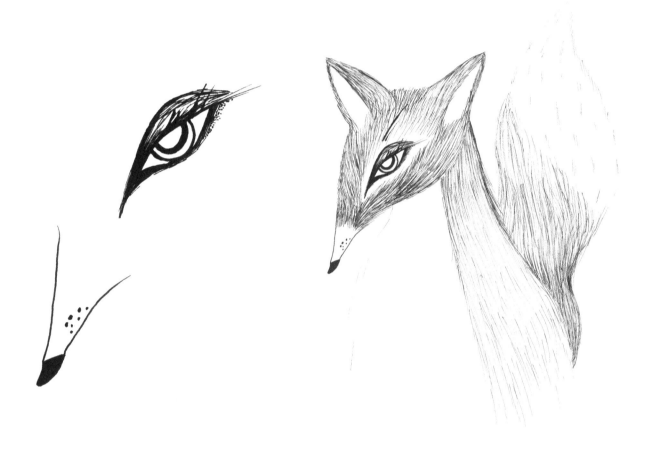

ARTIST'S TIP

If there's an area of your illustration that requires precision, begin your inking there. Once it's exactly the way you like, you'll be more relaxed as you continue to work. If you don't get it quite right at first, you can start over without having lost a lot of time.

Darken

Now darken some areas with a second layer of hatching to create shadows, and add black coloring around the ears. I left some space around the eyes and nose blank. Finish the eye, leaving the white highlight.

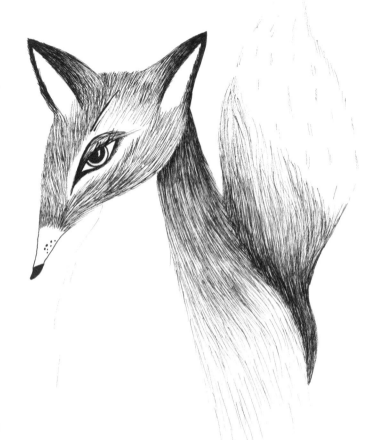

Adding Color & Shading

Mix india ink with water so that it is very opaque. Using an extra-small brush, paint loose lines with soft strokes to build the fluffiness of the fur around the fox's breast. I keep the brush quite dry to create a messy effect.

Mix a small amount of orange watercolor with the ink, and carefully paint the jaw and part of the fur to suggest color. If needed, you can also add shading with a transparent mixture of ink and water, covering the ears and other areas to create more depth.

Final Touches

Draw grass around the fox in a similar technique as for the fur on the breast, using quick, dry brushstrokes and darker ink. Keep your strokes confident.

Use a waterproof drawing pen to add details here and there. Step back to see if you're happy with the overall balance of the artwork. I decide to lighten the ears with a white gel pen and finish the tail with some additional strokes. I also add more shading and soften the fur with a bit of gray ink.

ARTIST'S TIP

A white pen or white gouache is the easiest way to correct small mistakes in your drawings.

BADGER: WORKING WITH OPACITY

The forest was covered in evening mist, and Mr. Badger was just about to enjoy
his breakfast, as he usually did before his regular walk in the moonshine ... This tutorial
explores monochromatic painting and working with different levels of opacity.
The opening illustration on pages 26–27 was created using the same technique,
but here we'll finish with touches of watercolor and gouache.

Sketch

Start with a pencil sketch on a sheet of cold-pressed watercolor paper. To avoid visible pencil marks in your final illustration, don't add too much detail. It's easy to add details later with ink.

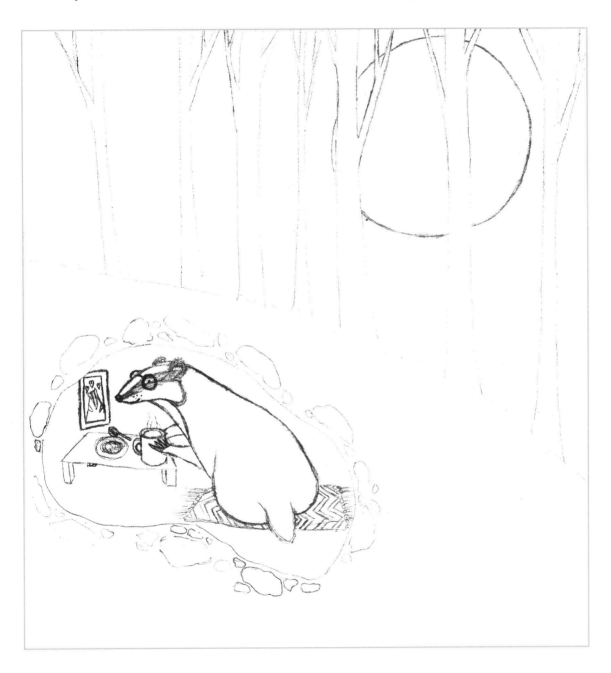

Materials

COLD-PRESSED WATERCOLOR PAPER	WHITE GEL PEN
HB PENCIL	WATERPROOF DRAWING PEN (0.3 MM)
INDIA INK	BROWN WATERCOLOR
WATERCOLOR BRUSHES (NO. 3 AND 0)	WHITE GOUACHE

Sky

Premix six gray colors on a watercolor palette. Fill one well with pure black india ink and add a little bit of water to each of the other wells. Take some ink from the first well and add it to the water in the other wells to create six opacity levels, as shown here.

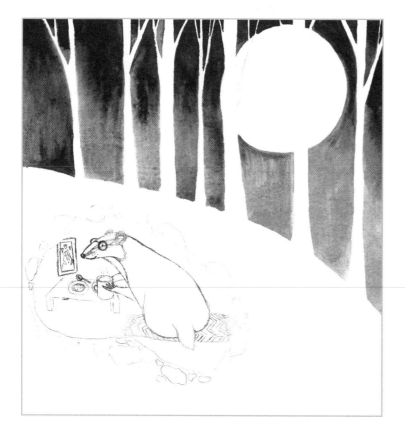

For the sky, start with the ink in the second well and apply it at the bottom, near the grass. To create transition in color, add pure black from the first well at the top edge of the sky while the ink is wet.

ARTIST'S TIP

An eraser can wear down the watercolor paper, affecting how it receives water and ink. I recommend waiting to erase any visible pencil marks until after you add the first ink layers.

Trees

Erase any visible pencil marks around the branches. Paint the trees in the same way as the sky, using the ink in the third well for the lower parts of the trunks and the ink in the fourth and fifth wells for the higher parts of the trunks and the branches.

Grass & Earth

Erase the pencil marks around the stones before applying ink to the ground. Start with a medium-gray shade and use messy, dry, circular strokes. The opacity is lower around the burrow and higher on the top, so work in layers and connect the dark top with detailed grass around the trees using black ink.

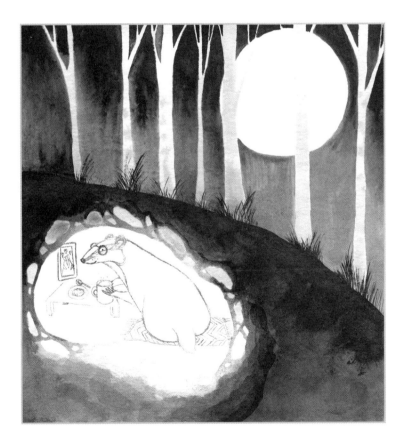

Badger & Burrow

Line art is simple and neat. Use a waterproof drawing pen to outline the furniture. For the badger, use a No. 0 watercolor brush to apply ink. When the ink is dry, paint a few lines of dark gray to accentuate the fur texture.

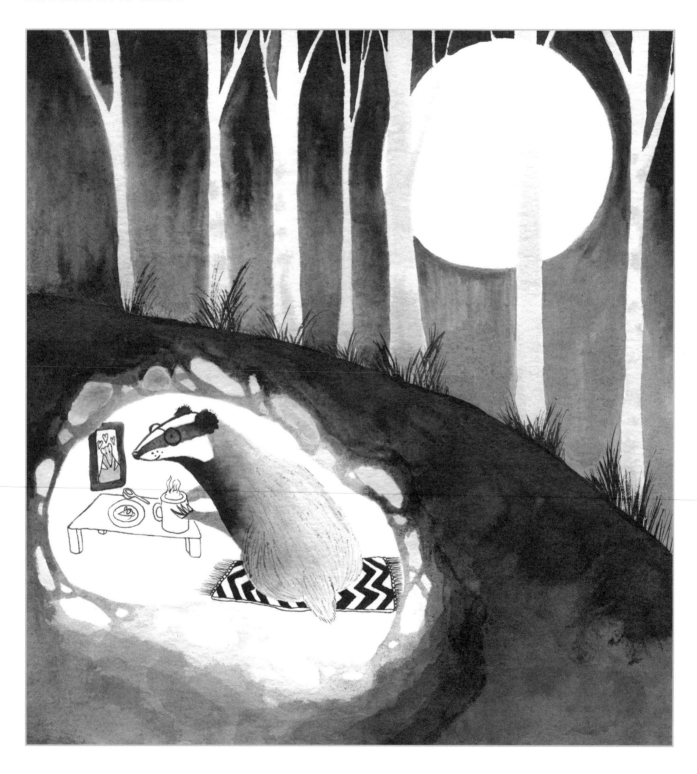

Color & Final Details

Use brown watercolor paint to add color to the burrow. Like working with ink, connect only the wet parts together to avoid sharp transitions. For the moon, apply a layer of water first, and then drop in a few dots of diluted brown watercolor paint to create a warm hue.

Once the paint is dry, use a white gel pen and/or an ink drawing pen to draw flowers, plants, and stars. I also add two smaller trees in the background. To finish, mix white gouache with water to lower its opacity, and paint the misty clouds.

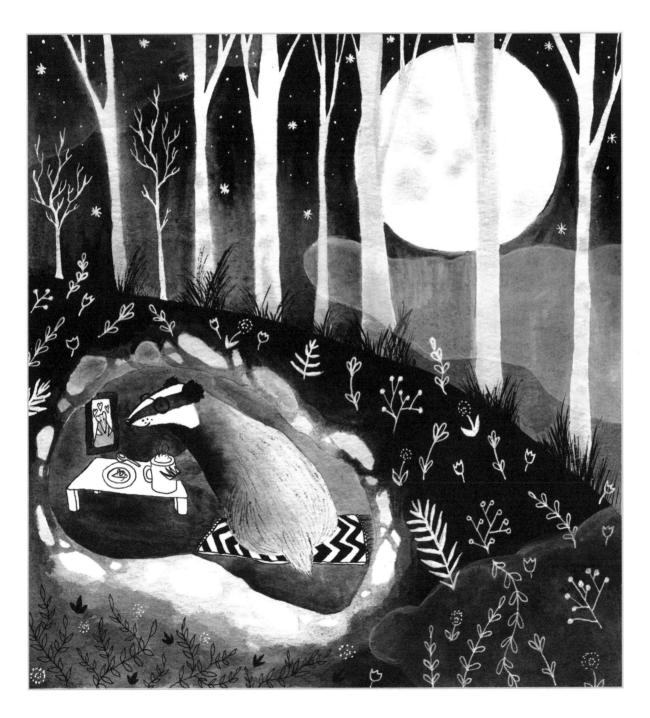

Fawn: Using Stippling

In this exercise, we'll explore using a stippling technique. This fawn is inspired by vintage children's books—mostly Russian—but you can also see some resemblance to Disney's Bambi. Keep the drawing minimalistic; this is usually best for stippling. A floral pattern enhances the vintage aesthetic.

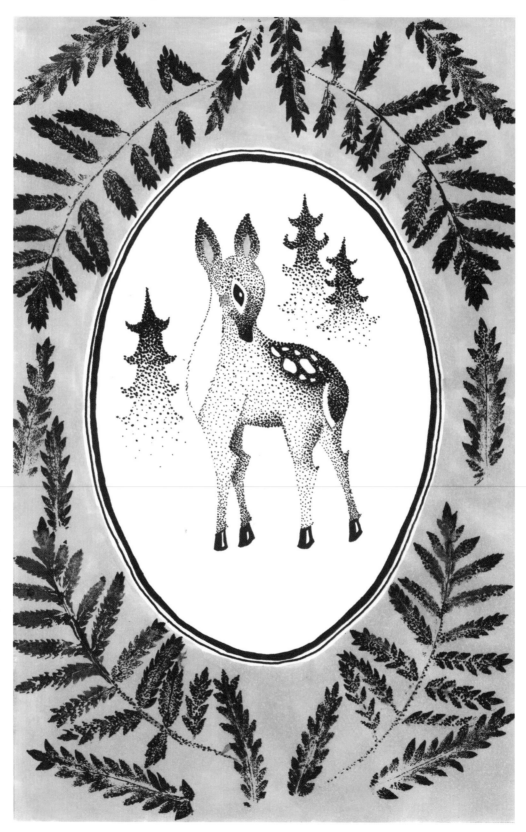

Sketch & Transfer

Make a simple sketch. Notice how mine isn't very realistic. When making a sketch for stippling, think about positioning contrasting objects and areas next to each other; otherwise, the parts of the objects will visually melt into one another. Transfer the sketch onto a new piece of drawing paper.

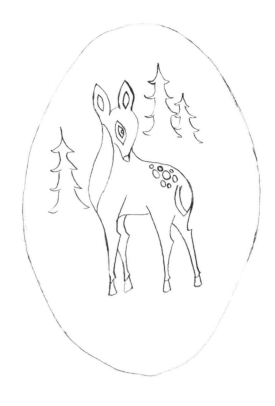

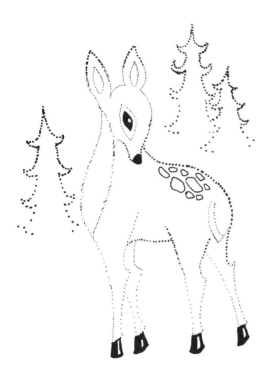

Outlines

Trace the outline using dots rather than solid lines. For darker areas, use a thicker drawing pen (1 mm or 0.8 mm). For lighter areas, place the dots farther apart. You don't need to follow the pencil sketch exactly. Once you're done, you can either transfer the drawing again onto a new sheet of paper, or erase the pencil marks. Some drawing pens smudge, so be sure the ink is dry before erasing.

Materials

DRAWING PENS (1 MM, 0.8 MM, AND 0.2 MM)

SMOOTH BRISTOL PAPER

ART MARKERS (OPTIONAL)

INDIA INK (OPTIONAL)

Stippling

Now it's time to stipple! Start making dots very close together. In darker areas, place the dots right next to each other, and use a thick pen. Fill in the light areas with a thin drawing pen. If you like, you can make a quick value study with your original sketch before stippling as a visual reference for where the shadows and light areas are.

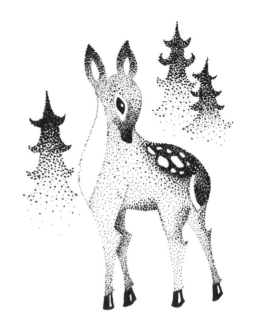

Touches of Color

If you like, add touches of color with an alcohol-based art marker. You can leave the drawing as is, or add a colored frame like I did, and doodle or stamp a design around the frame. To apply printed ferns like I did, follow the tips in "Fern Prints" on the next page.

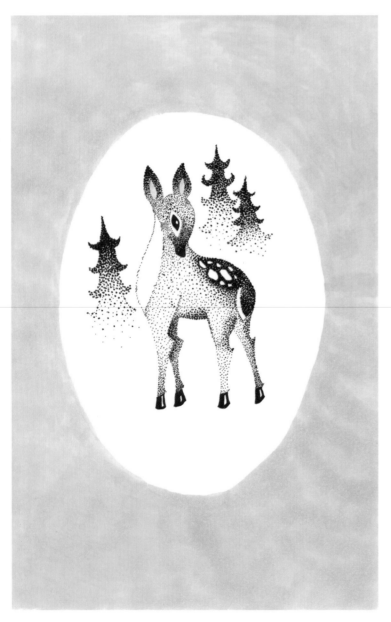

48

FERN PRINTS

I picked some ferns from my garden. Then I covered a piece of cotton with black india ink, placed a fern on the fabric, and folded it over to coat the fern with color. I used sheets of paper to protect the rest of my drawing, arranged the inky fern on the frame, placed a paper towel over the fern, and gently pressed it onto the drawing. Then I carefully removed the paper towel and fern. I used a clean paper towel for each print and added stippling in some of the open areas of the prints.

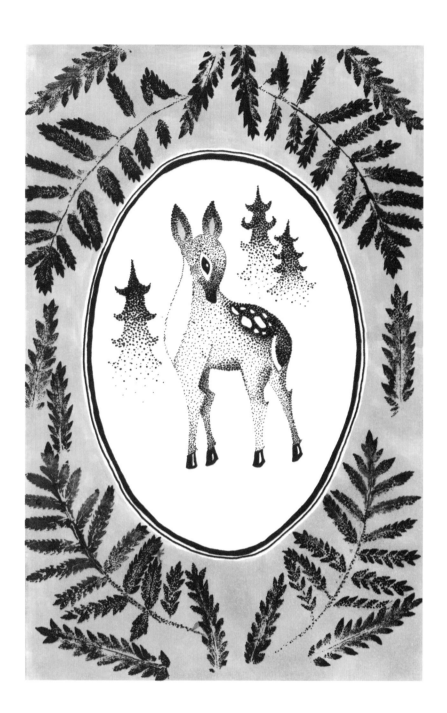

ARTIST'S TIP

Some drawing pens react with alcohol-based markers and appear to melt. It's a good idea to test how your pen reacts with your marker before using them together.

CREATIVE EXERCISE: HEDGEHOGS

A hedgehog is simple to draw. All you need to draw are the eyes and a nose, and then you can play with the design of the spines. The simple shapes of this animal are perfect for practicing various inking techniques and textures.

Stippling

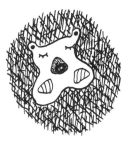

Hatching

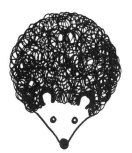

Crosshatching

Long Spines

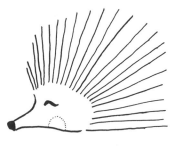

Scribble Texture

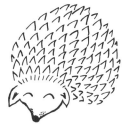

V-shaped Texture

Floral Spines

Brush Texture

White Spines

Practice Here!

Finish the illustrations on this page. You can use the examples shown on the previous page, or make up your own!

 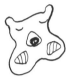

 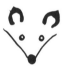

DEALING WITH ARTISTIC CLICHÉS

In a world full of creativity, art, and easy ways to share on social media and the Internet, there are myriad artistic fads and clichés. For instance, a big illustration cliché is the sleeping fox. It's such a cute and beautiful idea that everyone wants to draw it.

There's nothing wrong with wanting to create your own version of a popular concept, although it can be challenging to come up with something that's new and truly yours. How about taking your art one step further?

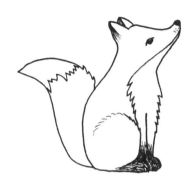 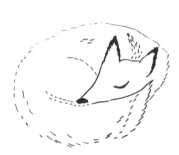 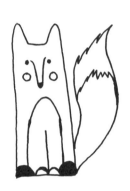 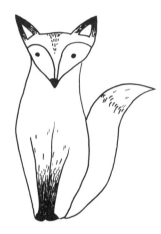

This illustration of four foxes captures contemporary drawing clichés found all over the Internet. The fox illustration tutorial on pages 34–39 draws inspiration from vintage artwork and culturally defined characteristics of a fox—all of which gives it its own style. Choosing your own point of view gives your artwork more depth.

HOW TO FIGHT CLICHÉS

- Study real animals—or photos and videos of them—and try to focus on your first impressions.
- Study contemporary illustration to know what current artistic clichés look like.
- Vintage illustrations and ancient artwork are great sources of new ideas—you could choose an approach that may not be completely new but hasn't been used for decades.
- Study stories that feature animals as characters—what does culture have to say about them? Do you agree or disagree with the general stereotypes about the animal? How can you use that in your illustration?
- Show the animal in a new setting or exaggerate one of its features or characteristics.

Practice Here!

Choose a woodland animal and search Pinterest®, Instagram®, or the web for common similarities in drawings of that animal. Focus on what positions people usually draw the animal in, what kind of eyes they give it, whether the drawings are detailed or simple. Then use this page to draw a few of the clichés in your own way.

DOMESTIC ANIMALS

Domestic animals are usually the first animals we learn to recognize as kids, so this section is dedicated to naïve art that appeals to children and the young at heart. We'll explore how to draw cute animals and simplify or exaggerate their features. With the techniques and projects on the following pages, you might make your own posters and art prints for nursery walls, beautiful educational drawings, or just for fun. You'll also explore the art of traditional collage and how to add human characters to your illustrations to capture the ideal version of our relationships with animals. Let's play!

Rabbit

My three-year-old's favorite game right now is pretending we're rabbits—we bake carrot cakes and sleep in a hat. Black-and-white art in nurseries is very trendy, but children love color! It can be challenging to come up with the perfect compromise between the things that children enjoy and their parents' taste. I created this illustration with my daughter's preferences in mind, asking myself, "What would she like to hang on her bedroom wall?"

The Sketch

Sketch the rabbit with an HB pencil on white Bristol paper. The rabbit's shape is extremely simple—three oval shapes and ears. Closed eyes add a dreamy mood.

Next, add florals and greenery to the sketch. A more complex flower arrangement balances the simplicity of the rabbit. You can use a photo reference for the flowers or invent your own abstract floral patterns.

ARTIST'S TIP

Bristol paper is perfect for alcohol-based markers, because it allows for smooth color transitions.

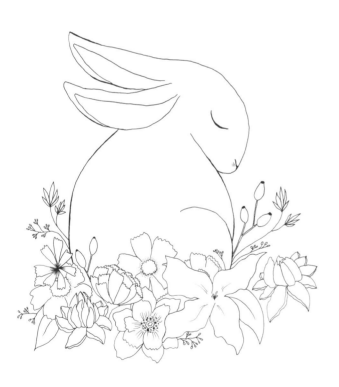

Line Art

Trace the sketch with a manga drawing pen, which is great for working with alcohol-based markers. As you trace, correct any imperfections and add details. When drawing the details of the flowers, your strokes should be quick, starting in the centers and progressing toward the edges.

Materials

HB PENCIL & ERASER
BRISTOL PAPER
MANGA DRAWING PEN

ALCOHOL-BASED MARKERS
GRAPHICS SOFTWARE (OPTIONAL)

Coloring with Markers

Add color. Alcohol-based markers are great for creating shading and color transitions. You can create beautiful effects just by layering the ink. Once the marker dries, it's more difficult to connect the layers and create smooth transitions between colors.

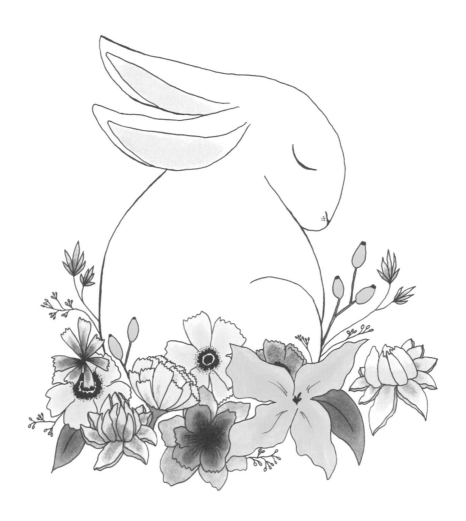

PALETTE

I LIMITED MY COLOR PALETTE TO PASTEL SHADES WITH LOW OPACITY. SHADING IS MUCH MORE DIFFICULT WITH OPAQUE SHADES.

Digital Background

You can also create digitized colored versions of the finished artwork. To do so, scan your artwork into your computer. Open the file in the photo-editing software of your choice, and add color to the background. I did this by selecting the background with the magic wand tool in Adobe Photoshop and adding color with the paint bucket tool. Use any color you like!

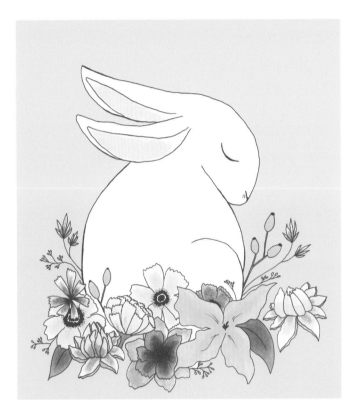

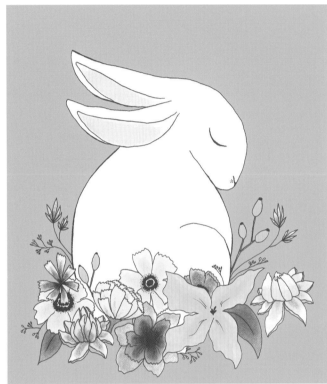

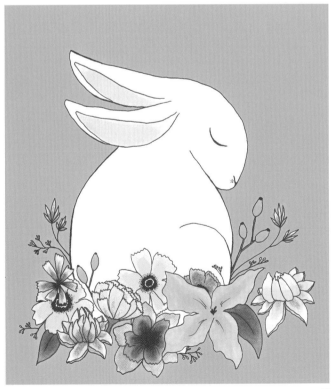

ARTIST'S TIP

Changing the hue and saturation of the background color also changes the mood of your illustration!

Guinea Pig

In this tutorial, we'll explore creating an illustration collection. The finished art would look lovely in a bedroom. It's also educational because it depicts different breeds of guinea pigs!

Illustration collections are a great way to practice inking with drawing pens—and you can "collect" anything you like. When drawing individual illustrations for a collection, try to capture the common features across the variations.

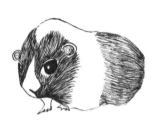 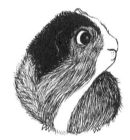 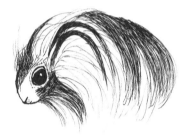

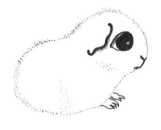 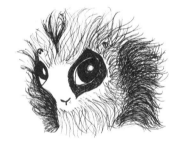 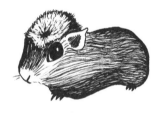

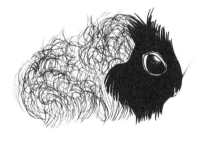 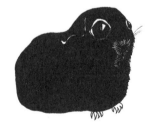 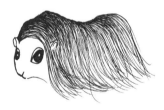

Materials	HB PENCIL & ERASER	JAPANESE DRAWING PENS IN VARIOUS SIZES
	BRISTOL PAPER	GRAPHICS SOFTWARE (OPTIONAL)

The Shape

The form of a guinea pig can be reduced to two irregular ellipses connected to each other. When you adjust the placement of these ellipses, you can create different postures for the guinea pigs.

The Sketch

Create the initial pencil sketch of each guinea pig. I try to capture the basic shapes without drawing many details. The big, elaborate eyes bring an element of cuteness into this drawing.

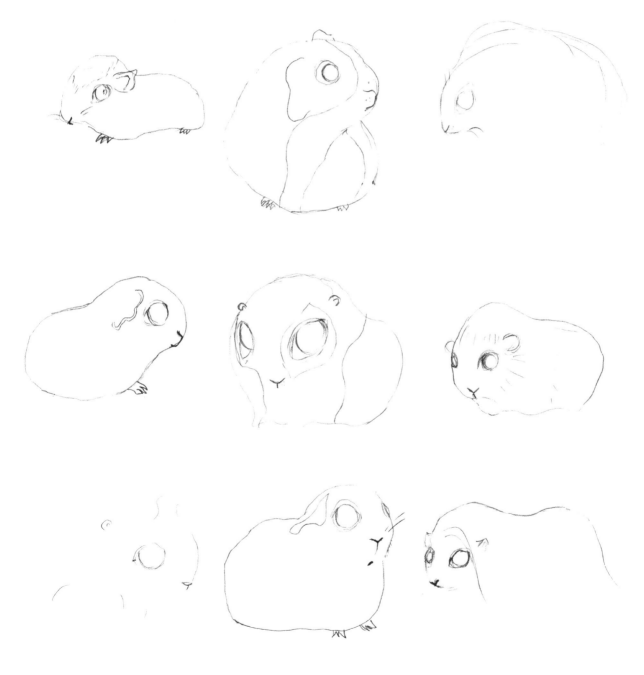

Inking

When you're happy with the pencil sketches, ink over the lines. I always begin with the eyes, nose, and ears. Then I start inking the fur. I don't draw all the lines; just those in places where contrast is needed for white fur on a white background.

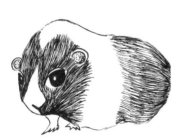 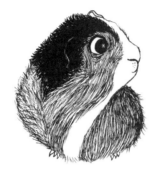 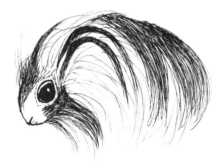

The texture of the fur is important, and it marks the difference between individual breeds. You can instantly see whether a guinea pig is fluffy or shorthaired.

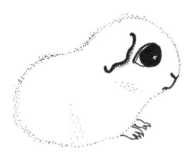 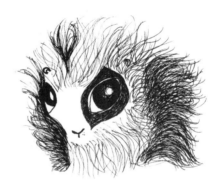 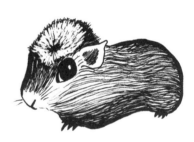

The easiest way to create contrast on a dark background is to leave the pencil outlines white. Another way is to use dark texture to make it obvious that everything is black. When I draw long hair, I work quickly, lifting the pen at the end of each stroke to taper.

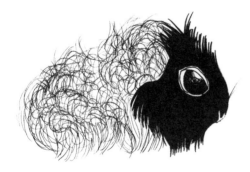 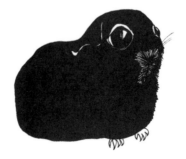 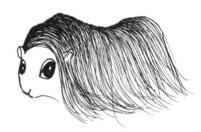

Digital Work

If you like, you can finalize the illustration digitally. I scanned the artwork and put the illustration together digitally in Photoshop. It was easy to add text and experiment with different typefaces. I was also able to adjust the sizes of the guinea pigs so they aren't all the same. When you plan your sketch ahead of time and use a ruler to divide the space of the paper, there's no need for digital postproduction, but it's a nice alternative!

Guinea Pig

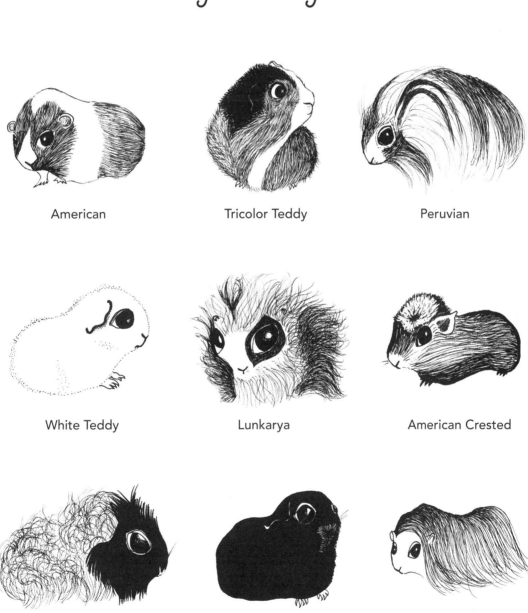

American

Tricolor Teddy

Peruvian

White Teddy

Lunkarya

American Crested

English Merino

Black Coronet

Silkie

Donkey

I love drawing and painting children's interactions with animals, especially if the animals are big and strong. Children who grow up with animals are fearless and include them in their games and daily activities, and animals usually respect them— and can overlook their behavior when it crosses the line—because they innately understand that they're small and vulnerable. This sweet illustration could be in a children's book or a coloring book, or it could go on a wall in a child's bedroom.

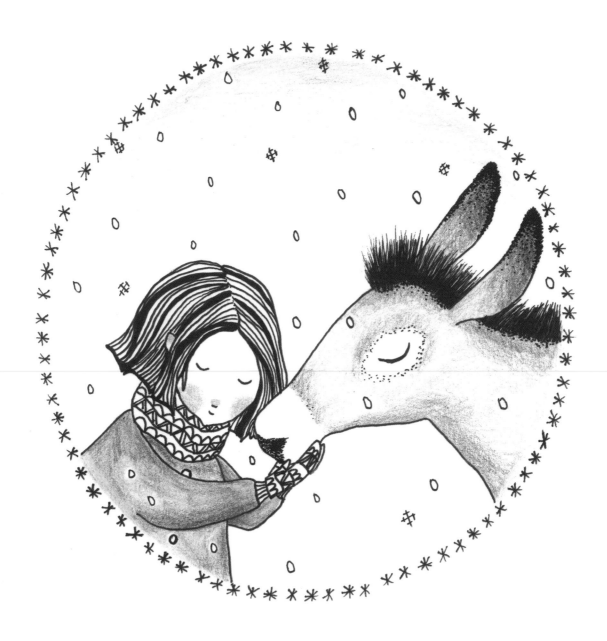

The Sketch

Draw a circle frame for the image and sketch the two characters inside. I start with some basic shapes forming the donkey's head. Then I draw the shape of the girl's head. I try to think ahead to where would I place the darker areas, knit patterns, and so on.

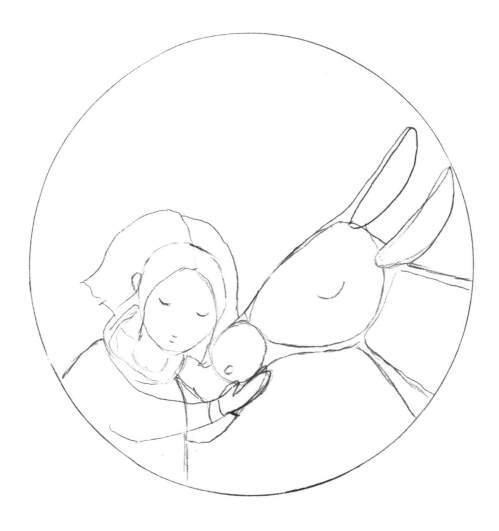

Materials | HB PENCIL & ERASER DRAWING PEN (0.2 MM)
 | BRISTOL PAPER COLORED PENCILS

Main Outlines

Trace the main outlines with a thin drawing pen and erase the pencil.

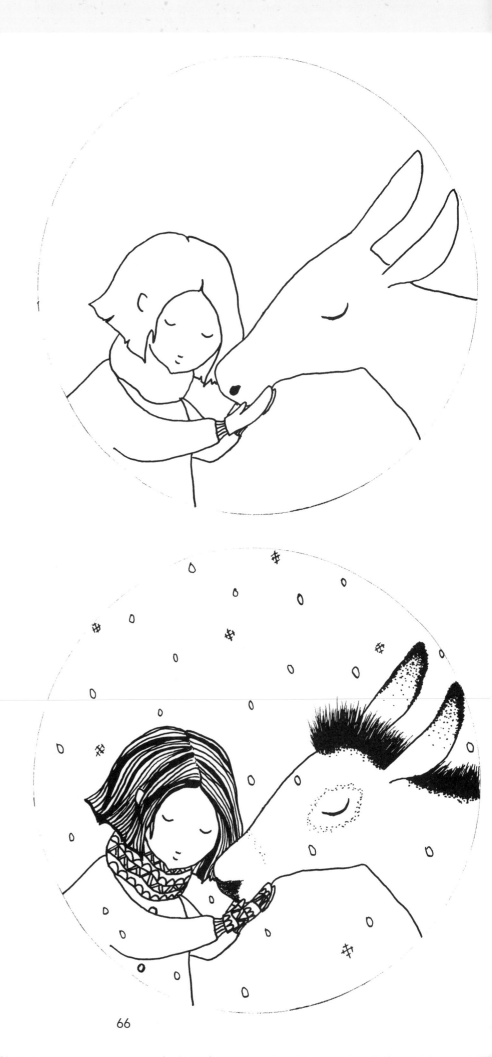

Inking the Details

Ink the details of the illustration. Stippling makes the ears appear fluffy. Use quick, narrow strokes for the mane, lifting the pen with each stroke so that the tips are slightly thinner than the roots. Divide the girl's hair into darker and lighter sections, and draw the details of the knitwear. Add snowflakes over both characters, and fill the round shape of the frame with them.

Coloring with Pencils

Add simple color with well-pigmented colored pencils. I use several shades of gray, red-brown, and black to add depth to the illustration. I work in layers when coloring and prefer a limited color palette, so that the simplicity and main message of the illustration stand out. Add a frame of simple snowflakes around the original circle.

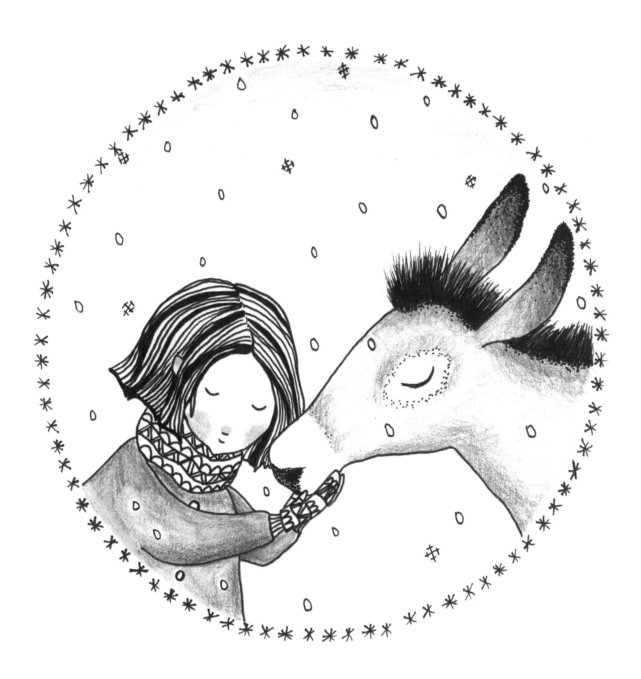

COLLAGED CAT

Traditional collage techniques are perfect for creating playful illustrations. If you have little ones around, this is something they can help with—or they can create their own collage! Instead of using india ink, we'll work with oil-based ink for this technique.

Ink Textures

Apply oil-based ink for linocut printing on a
glass slab, and spread it all over with a roller.

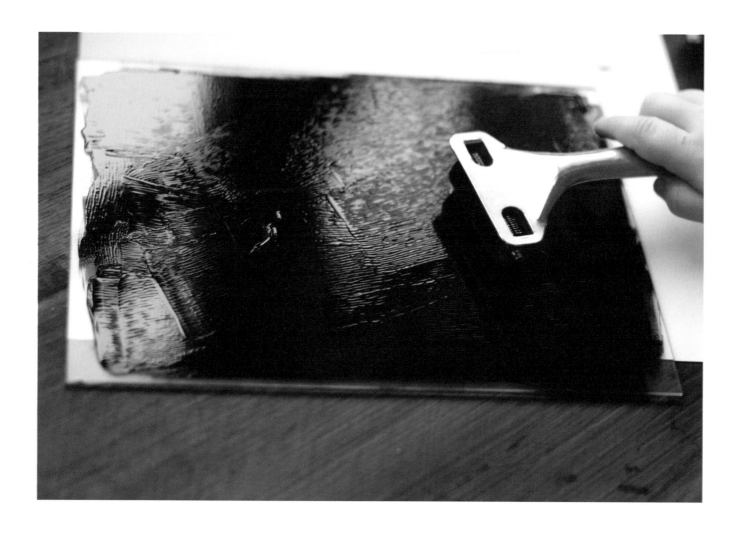

Materials

OIL-BASED INK FOR PRINTING	SHARP SCISSORS & MANICURE SCISSORS
PRINTMAKING PAPER (280 G/M2)	WHITE GLUE
ROLLER	OLD BRUSH
SPONGE	TWEEZERS
GLASS (E.G., FROM A CHEAP PHOTO FRAME)	

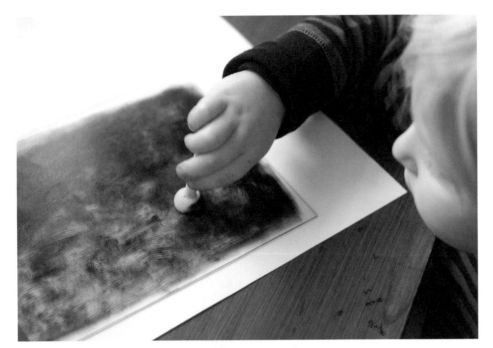

Move the ink around the glass with a sponge to create an uneven texture. There's no way to make a mistake here, so have fun with this step!

Lay out a sheet of printmaking paper and press the newly created texture on the glass to the paper. Use a roller to apply even pressure.

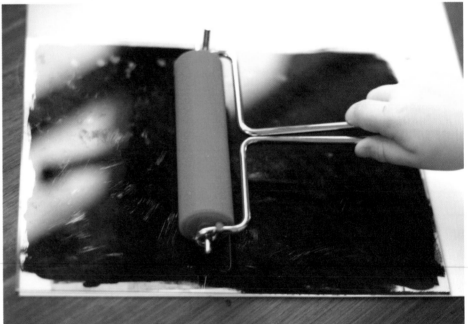

ARTIST'S TIP

We used rollers, sponges, and glass, but feel free to work with anything that will create an interesting texture on paper, such as plastic bags, fabric, or paper towels. You could also use india ink and a spray bottle.

Use the roller and ink to cover the rest of the paper with uneven texture.

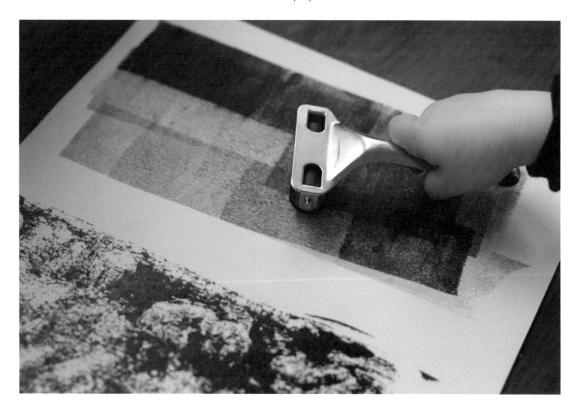

Again, apply the ink randomly. There's no right or wrong way to create texture.

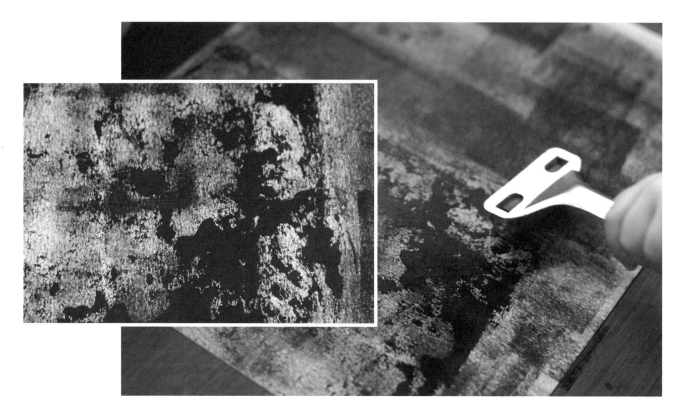

Cutting Out Shapes

Cut out some simple geometric shapes. You can plan ahead, but it's even better to improvise—you may be surprised by the outcome!

Use large scissors for bigger shapes and manicure scissors for small shapes.

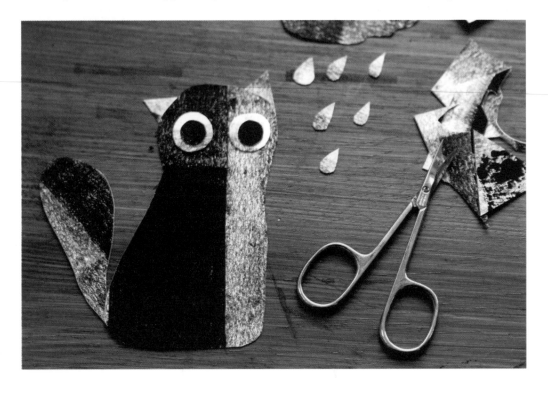

Collage

Play with the shapes and move them around to create a few versions of your illustration. Once you're happy with the result, glue the shapes onto paper. I use white glue applied with an old brush. Position the smaller shapes on the paper with a pair of tweezers to avoid smudging the glue over the paper.

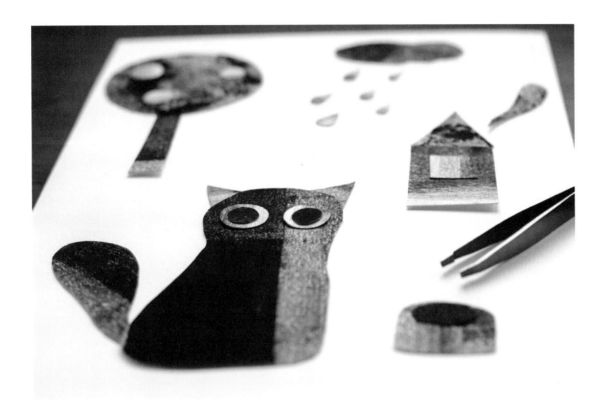

ARTIST'S TIP

Before gluing the shapes to the paper, you might try creating a short stop-motion animation of your illustration. Take a picture of your idea with a camera or smartphone. Then move some of the shapes around (like the eyes, raindrops, and ears) to tell a simple story. Take another picture, and piece the photos together in an app for editing video or stop motion.

Minimalist Dogs

Reducing information to include only the main features is the perfect
way to simplify and create sweet artwork for children—or just a minimalist style!

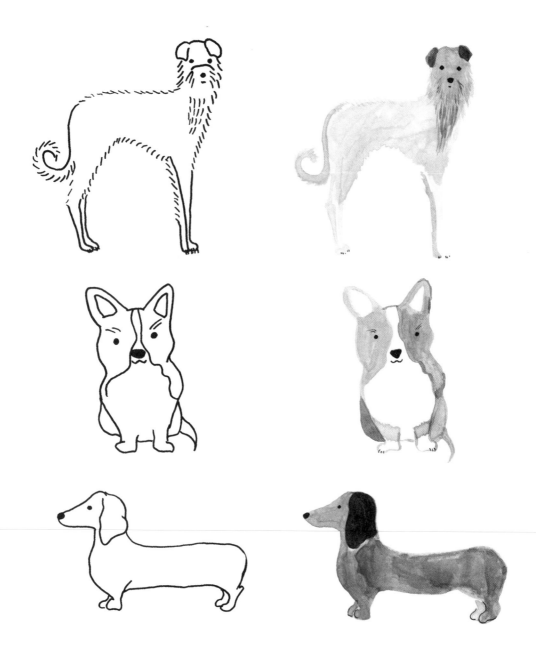

I drew these various dogs in a minimalist style. For each dog breed, I start by learning its main features—
giant ears, hair resembling dreadlocks, extra slimness, etc. Then I try to capture those features with just a
few simple lines and a thick drawing pen, which pushes me to leave out the details.

To finish, I use diluted ink and a thin watercolor brush to create texture and make the lines more interesting,
while still keeping it simple.

Choose three to four dog breeds that you like, and sketch them with pencil. Try to discover their most prominent features and reduce the drawing to those features. Take it a step further by inking the dogs and applying diluted ink to create texture.

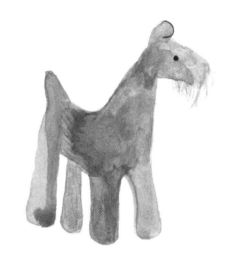

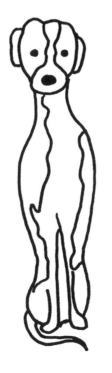

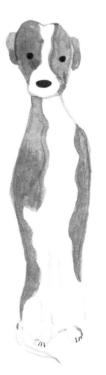

DRAWING CUTENESS

What do you find cute? For many people, it's human and animal babies! Adding childlike features to animal characters ups the cuteness factor of your illustration work.

Adults vs. Babies

Practice by drawing baby animals and noting the differences between babies and their adult counterparts.

Sheep

Lamb

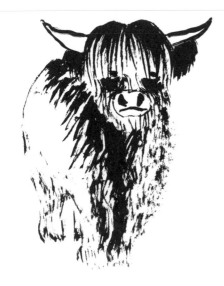

Highland Cow

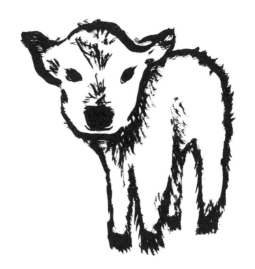

Highland Calf

Fluffiness

Young animals tend to have soft, fluffy fur. You can paint fur with a dry brush and india ink, as shown here, but there are many ways to create this texture. Find your own way to capture fluffiness using various tools and inking techniques.

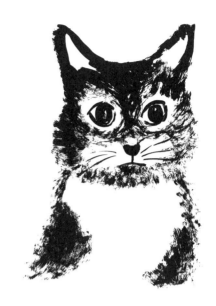

Exaggeration

A popular trend in illustration is to exaggerate all those cute features. You can make the eyes or the head bigger, or do something else entirely—it all depends on your taste. Be discerning about exaggerated features, however, as they can also turn into kitsch.

 CUTENESS FACTOR CHECKLIST

[] BIG, ROUND HEAD [] SMALL NOSE [] NO CHIN
[] LARGE EYES PLACED [] SMALL MOUTH [] NO NECK
 LOW ON THE HEAD [] FLUFFINESS

Stylization

Adding babylike features isn't the only way to draw cute art. You can also play with proportions and add more human features, such as cheeks or closed eyes, which make your illustration dreamier. Even "ugly" animals can become amazingly cute with some stylization!

| Realistic Proportions | Simplified Proportions | Stylized Proportions |

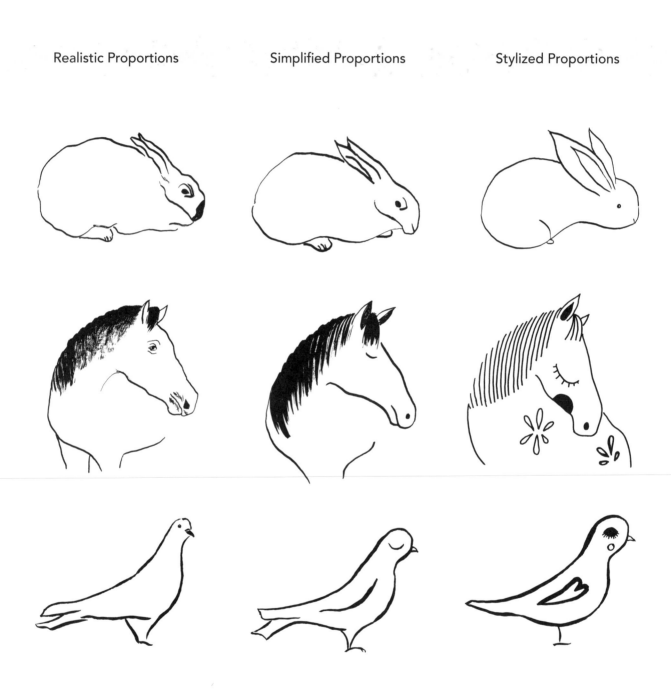

Practice Here!

BIRDS

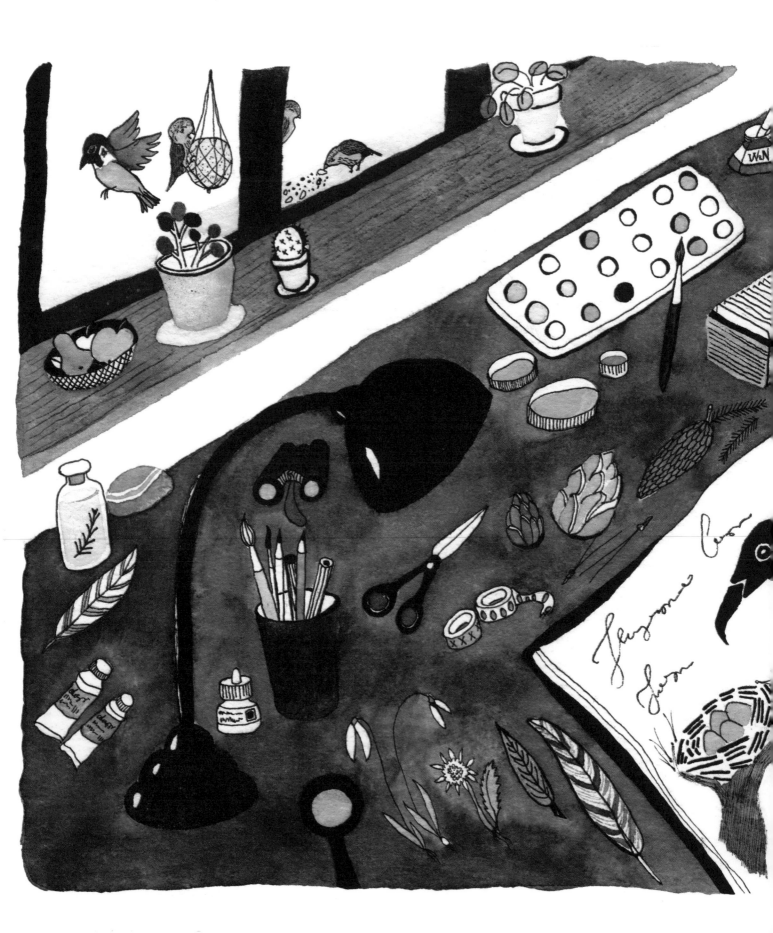

This chapter is all about nature illustration. We see birds every day—whether or not we notice them—which makes them great for capturing in a field journal. We can examine many details of their appearance and behavior, such as feather shapes or style of flight! Many naturalists become artists because they want to capture special moments in their field journals, and it works the other way around too: Many illustrators draw inspiration from objects in nature.

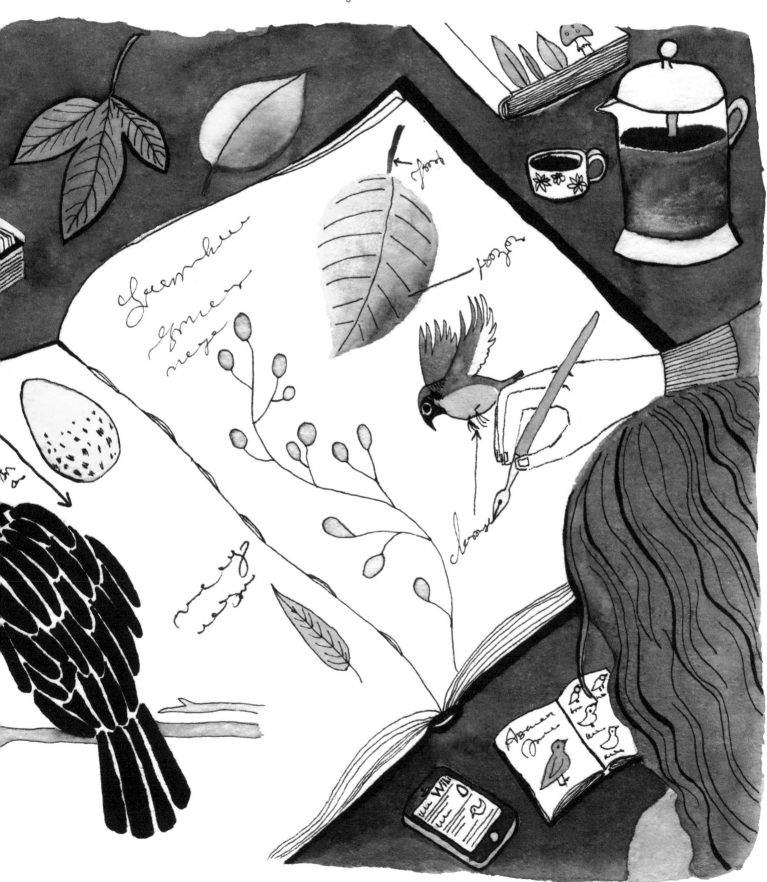

Field Journal: Woodchat Shrike

If you like a naturalistic style of illustration and walks in nature, start your own illustrated field journal! It's a great way to learn to observe and discover new illustration methods. The best kind of journal for this purpose is one with watercolor paper so that you can use both dry and wet media.

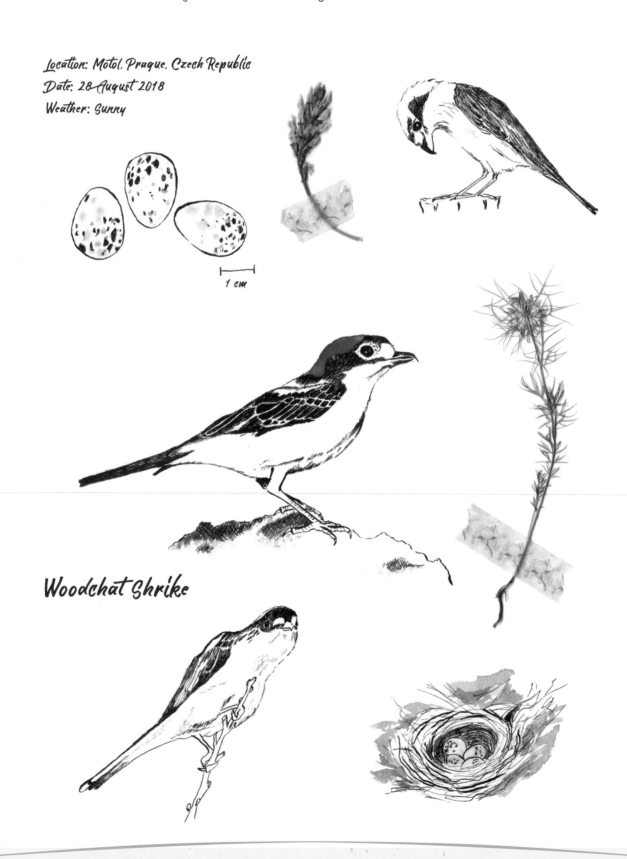

Location: Motol, Prague, Czech Republic
Date: 28 August 2018
Weather: Sunny

1 cm

Woodchat Shrike

THE BENEFITS OF KEEPING A FIELD JOURNAL

A field journal essentially becomes your own miniature atlas of birds and other animals—you capture what you see on walks and learn more about nature and the animals around you. You can write down which species you saw, when you saw them (because some animals can only be observed in certain seasons or at specific times of the day), location (a forest, a meadow, the bushes, etc.), and the weather conditions. You can capture the differences between the male and the female, write about its voice, and draw the feathers, nest, or eggs. You can also add a scale to remember the real size of the drawn object.

While field journal illustrations tend to be realistic and somewhat scientific, illustrators often approach them with a certain level of stylization. In the past, this used to be the only way to capture what you saw, but nowadays you can also use a camera or a smartphone and finish your sketches at home! Field journaling is a beautiful hobby and, when combined with birdwatching, it can inspire you to spend wonderful days walking outdoors and drawing.

Shapes

It's difficult to sketch birds quickly enough to do it on location. Practice, and know that it takes some time to get comfortable with quick sketching. It's helpful to observe your location and your target with a camera and take photos. Then choose the right photograph to work from. It should showcase a typical posture for the bird; this will help you recognize it the next time you see it.

Once you have chosen your photo, observe the basic shapes of the bird's body. Start your sketch with these shapes. Here, I've identified the shapes in this woodchat shrike.

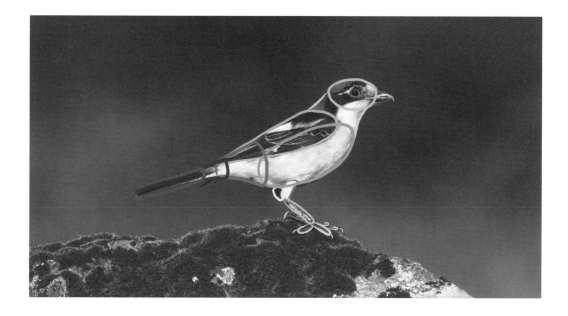

Materials

CLASSIC NIB PEN	WATERCOLOR PAPER
INDIA INK	CAMERA

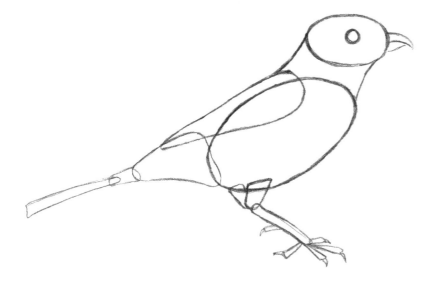

Once you've identified the shapes, start your sketch with rough pencil lines.

The Sketch

Redraw the bird silhouette on watercolor paper (or in your journal, depending on what medium you decide to use). Keep the pencil outlines light so that they won't show up in your final illustration.

Inking with a Dip Pen

Try a traditional inking technique with a dip pen and a flexible nib, or choose another inking method! Trace the sketch with short hatching strokes. Lines created with a nib pen leave a lot of space for personal artistic style. You can be precise or messy, alternate dark areas with light spaces, or fill everything in—it depends on your preferences. Be careful to dip only the nib's tip so you don't create inkblots on the drawing. Keep plenty of napkins and water nearby to clean the nib when the ink starts to dry. You can also leave the pencil lines visible under the sketch. This works well in a field journal, since some of the other sketches might be in pencil.

Color

Add color to the drawing with watercolors or colored pencils. I add just a few watercolor touches to mine.

Your Journal Page

You can add other sketches of your bird in less typical angles. Add details that you noticed in the field, such as eggs, their size, the shape of the nest, etc. You can even add photos or dried plants that you collect onsite. And don't forget the description! Add the name of the bird, place, time, weather conditions, and anything else that might be interesting and helpful for spotting and recognizing this bird next time.

NESTS

While you probably won't come across a bird willing to sit still and let you sketch it in the field, you might see a nest you can sketch during your outdoor art trips. You can also add nests to the pages of your field journal to describe the birds that you meet and complete the overview. Is there anything special about the bird's eggs or the kind of nest that it builds? Draw it!

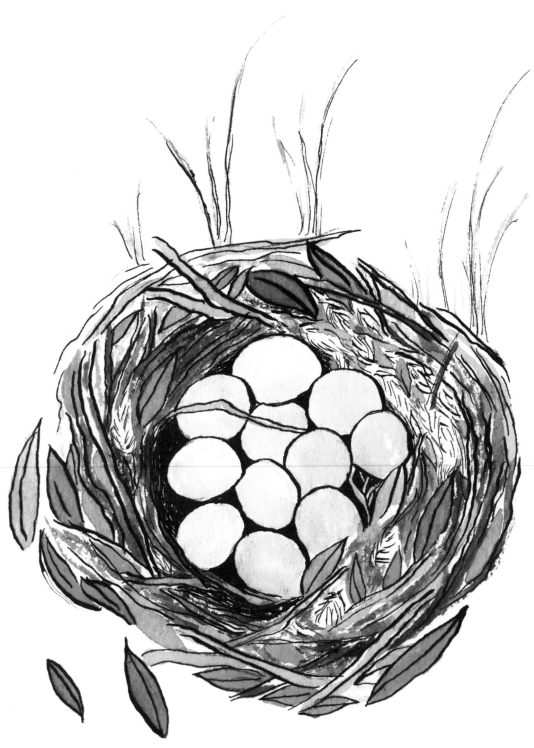

Inking

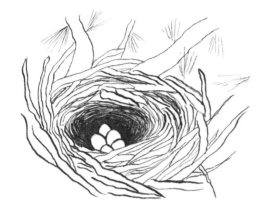

Raven

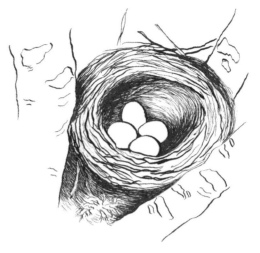

American Robin

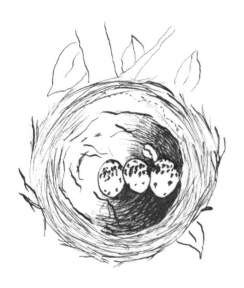

Yellow Warbler

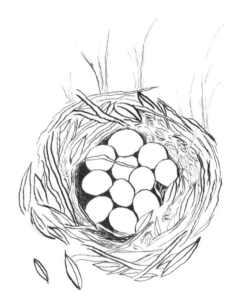

Wild Duck

Materials | INDIA INK WATERCOLOR PAINTS
NIB PEN WATERCOLOR PAPER

Coloring

Ink illustrations are often colored with watercolors. You don't need to color everything, however. Use watercolors to accent unusual or characteristic features on a bird. Once the ink is dry, you can add color without smudging.

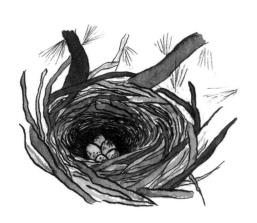

Raven

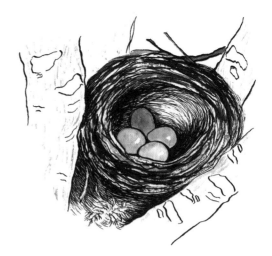

American Robin

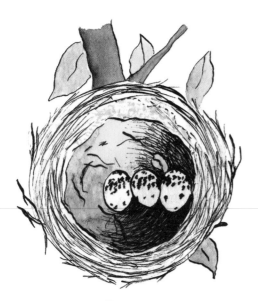

Yellow Warble

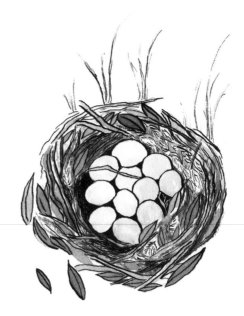

Wild Duck

ARTIST'S TIP

Never press on the tip of a nib. This might tear the paper and get it stuck to the nib. If this happens, clean the nib with a paper towel and water.

Practice Here!

Think of some other objects in the lives of birds or other animals that you'd like to capture in your field journal. Collect and sketch them here.

THINGS TO NOTICE

- OVERALL SHAPE OF NEST
- NUMBER OF EGGS
- EGG COLORS
- MATERIALS (E.G., FEATHERS, LEAVES, BRANCHES)
- DIRECTION AND SHAPES OF GRASS, STICKS, ETC.

Owl in Flight

Realistic drawing with a nib pen is probably the most common technique for field journals, but there are other interesting techniques to try as well. This inking method is similar to the techniques used for the bear on pages 28-33, but it demands precision and a more elaborate approach for adding details. In this case, you can't use a window to transfer your sketch, but you can still redraw it lightly on paper and paint over it with ink!

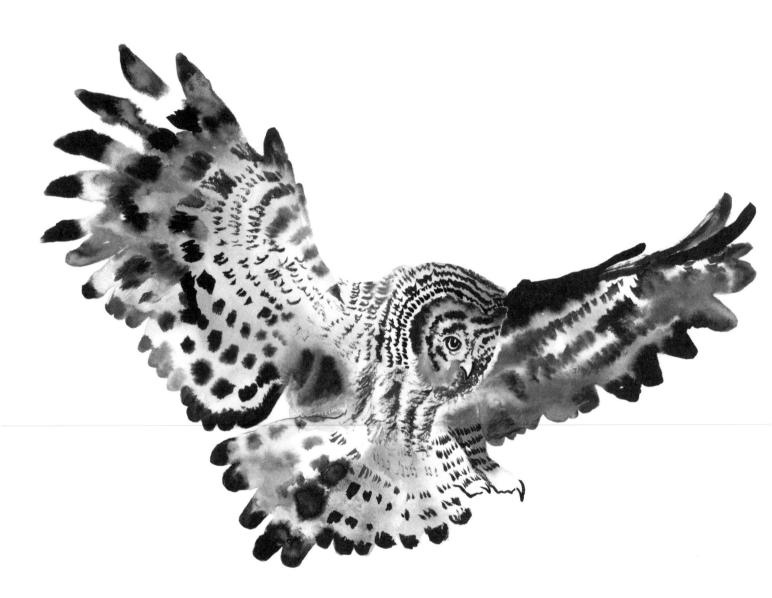

Silhouette

Start by sketching the silhouette of the owl of your choice. Use a pencil and plain copy paper for the sketch. If you don't feel confident about your silhouette sketching abilities, practice the exercise on page 106. After drawing the silhouette, mark some of the lines for the feathers, eye, and any other important features.

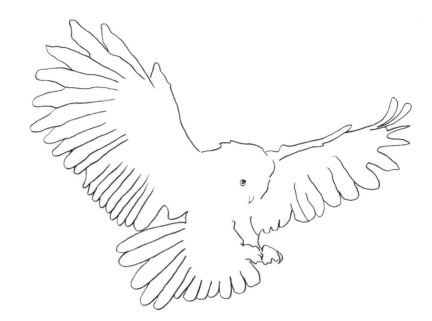

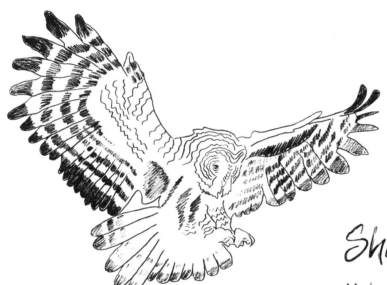

Shadows & Dark Areas

Mark all the dark areas in the sketch: feathers, shadows, etc. You can skip this step, but a light box makes it easier to transfer the shadows to your ink painting.

Materials		
	COPY PAPER	WATERCOLOR BRUSHES (NO. 0 AND 00)
	BRISTOL OR WATERCOLOR PAPER	PENCIL
	INDIA INK	LIGHT BOX (OPTIONAL)

Light Box

Place a sheet of white Bristol or watercolor paper over the sketch on a light box. All the dark areas and important lines will be visible through the paper. Choose an area to work on, and use a watercolor brush to cover it with water. It takes a little practice to learn how big of an area to work with—it needs to stay wet while you paint over it. Depending on your desired level of detail, you can work feather by feather or cover the whole wing with water.

Inking

Apply ink where you applied the water. When you're inking, more water on the painting means less control. Less water is great for adding darkness to the feathers; add details once it dries. Try to follow the wetness of your painting, working on the parts that are just as wet as you need them to be at the moment.

Work on one area at a time to finish applying ink to the illustration. Allow to dry.

It might take some practice to control the wet effects, but you can still achieve interesting results without perfect control. I love the fact that ink is always surprising!

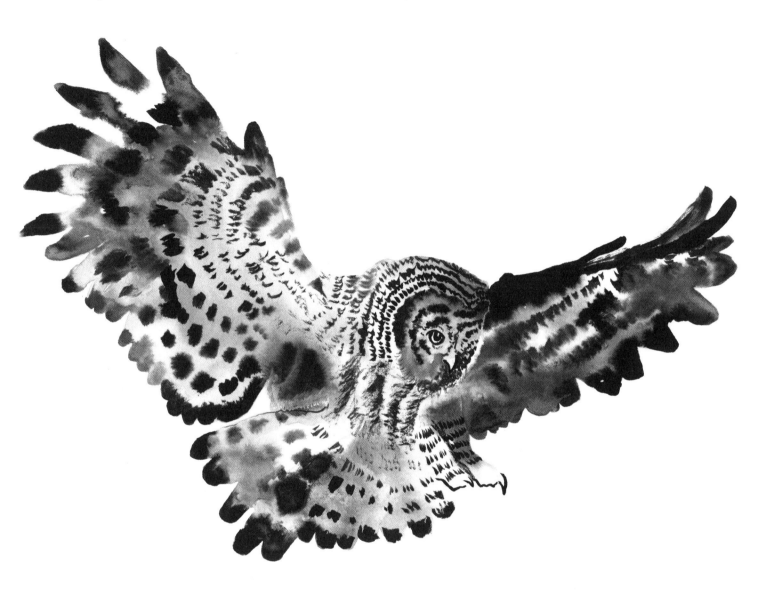

WORKING WITHOUT A LIGHT BOX

If you don't have a light box, you can use a window to lightly trace your original sketch. Apply your ink washes, and allow the piece to dry before gently erasing the pencil marks.

Sparrow & Other Small Birds

What I love about painting birds is that they allow you to explore different levels of abstraction—from very simple illustrations to extra elaborate ones. Watercolor birds are one of the first things I painted when I started experimenting with illustration. I basically created watercolor dots on my paper and added a beak, eyes, and legs. Once you learn to create different bird shapes, you can create amazing illustrations this way!

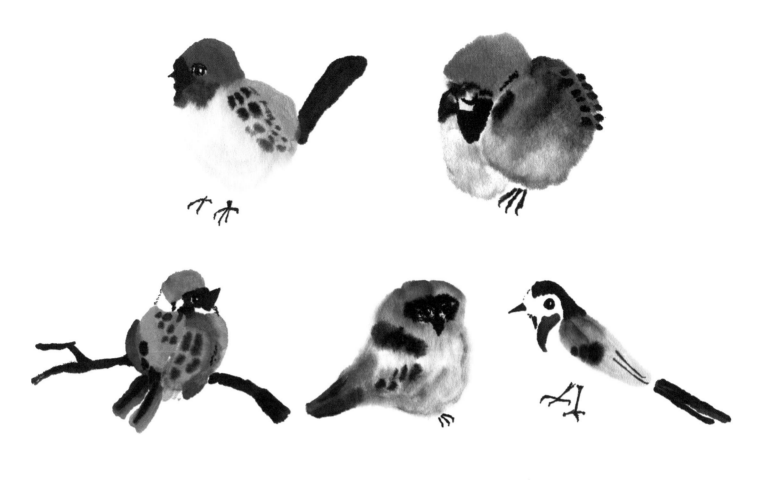

MY INSPIRATION FOR THIS COMBINED INK-AND-WATERCOLOR APPROACH COMES FROM JAPANESE *SUMI-E*, OR THE TECHNIQUE OF INK WASHES DONE WITH BLACK INK. YOU CAN PLAY WITH SHAPES AND COLORS, AS WELL AS THE LEVEL OF ABSTRACTION AND SURREALISM. IT'S UP TO YOU!

Materials

INK	SUMI-E OR WATERCOLOR PAPER
WATERCOLOR PAINTS	DRAWING PEN (0.2 MM)
WATERCOLOR BRUSHES (NO. 2 AND 0)	

Ink & Watercolor Blobs

Examine the shapes of the most prominent parts of the bird and paint them on sumi-e or watercolor paper. I use diluted ink for gray and dark areas and one or two watercolor shades. You can intentionally omit some parts of the bird and let your imagination go wild.

Adding Details

You can add as many details as you like with a thin brush and ink. I usually paint dark feathers, a branch, etc. Be sure to check the level of wetness while painting—it should be wetter for loose, fluffy effects and dryer for more precise lines.

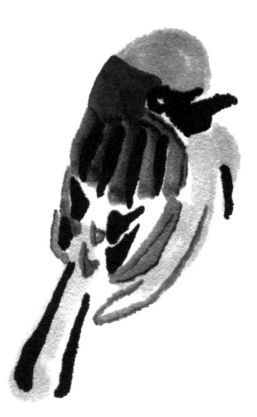

You can wait until the painting is completely dry, or draw in the wet paint with a drawing pen. The ink bleeds into the wet parts when you work wet-into-wet. When you work on dry paper, the ink stays precise.

ARTIST'S TIP

The ink from your drawing pen will be less precise when you work with sumi-e paper. Even with completely dry paper, you will notice some bleeding. If you want to give your painting a precise, neat finish, use watercolor paper instead.

Raven Linocut Print

Let's try something different and use ink for printing! I don't consider myself a printmaker, but I like to try new art techniques. Making a linocut is a fun way to reproduce an art piece. It's not a technique you would typically use in a field journal, but birds are great subjects to simplify and stylize for cutting and printing. This raven has a realistic silhouette and feather positioning, but it's surrounded by stylized plants.

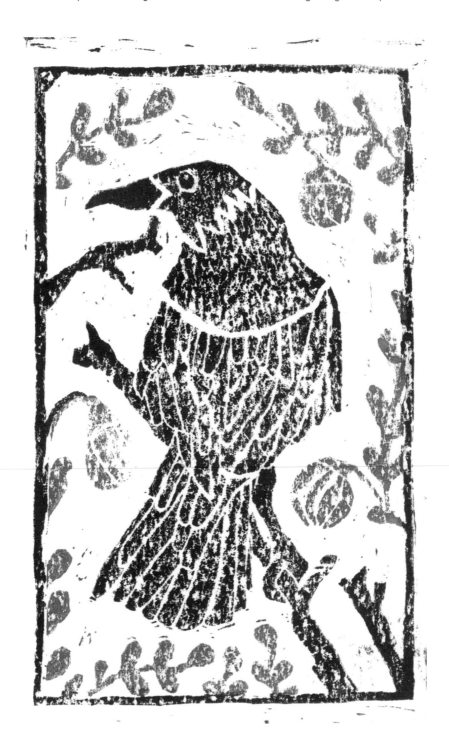

Sketch

I use my tablet to draw the initial sketch digitally. Using certain thick-lined tools in my drawing application helps me imagine what my finished linocut will look like—plus I can easily erase lines I don't like! You can create your sketch using a pencil, and then trace it with a marker. It's important to avoid too many details, which are difficult to carve.

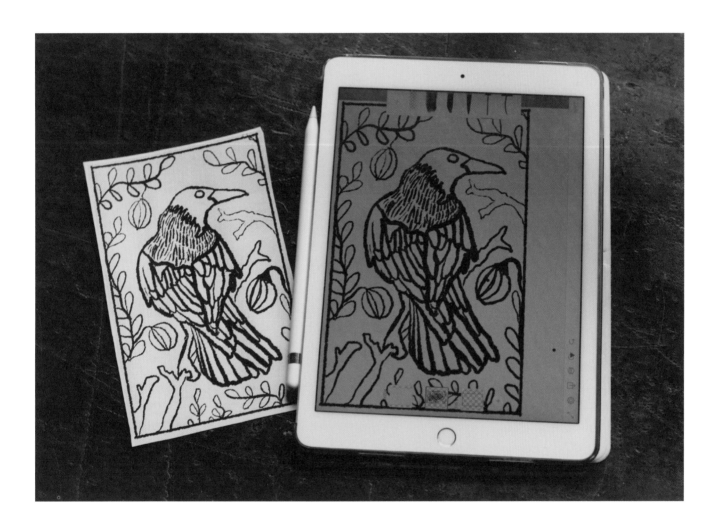

Materials

LINOLEUM BLOCK*

CARVING TOOLS & BLADES

WATER- OR OIL-BASED INK FOR LINOCUT PRINTING

GLASS PLATE/PALETTE*

SPOON

INK ROLLER

PRINTMAKING PAPER

CHARCOAL OR GRAPHITE PENCIL

*NOTE: YOU CAN FIND LINOLEUM BLOCKS AND GLASS PLATES FOR PRINTMAKING AT YOUR FAVORITE LOCAL OR ONLINE ART-SUPPLY RETAILER.

Transfer

There are several ways to transfer a sketch onto a linoleum block. I decide to use charcoal. For this technique, cover the whole back side of the sketch with charcoal.

Trim the linoleum block to your desired size, and put the dark side of the paper on it. Then trace the original sketch with a pencil and voilà—the outlines appear on the linoleum.

Since charcoal is a very loose medium, I like to trace the outlines one more time with pencil, and then brush off the charcoal layer. This extra step makes carving the design even easier! (See the next page.)

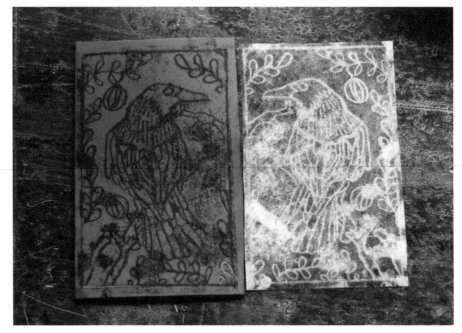

Linocut

I recommend starting with the narrow, less challenging areas of your design, such as the outer border, to test the carving tools. Once you feel comfortable, move on to more difficult areas. I use a small blade for the details and a larger blade to carve out the background and other areas that require less precision.

Keep in mind that some details might disappear in the prints, so it's best to imagine the overall impression without small details. The parts that you cut out will be white on the print. Do you want a white background? Do you want your outlines to be white or black? Don't forget to think this through before you start cutting! Everything will be reversed.

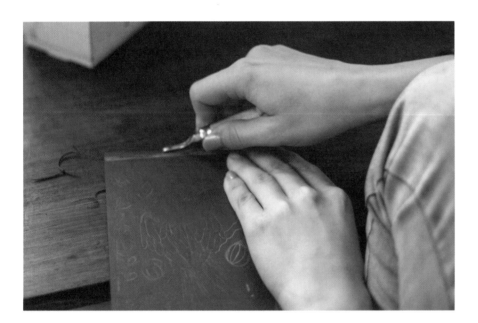

Work slowly as you carve to allow for more precision and to avoid cutting yourself. Always cut away from your body, and keep all your fingers behind the blade. Never point the blade toward your hand. Move the linoleum around as you work to keep the blade pointing away from your hands and body.

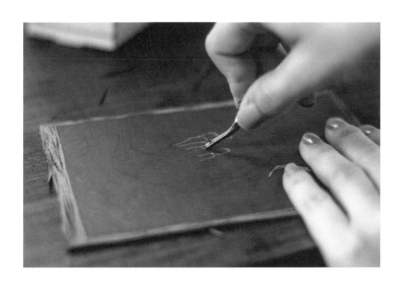

ARTIST'S TIP

If you make a mistake in your carving and cut off a small piece that you wanted to keep, you can try to glue it back on. If the area that you need to fix is big, carve a separate block to print over it.

Printing

Apply ink to the glass plate. I like to apply less at first and then add more if the color isn't thick enough after the first print. Use a roller to spread the ink all around the glass and allow it to create its characteristic ink texture.

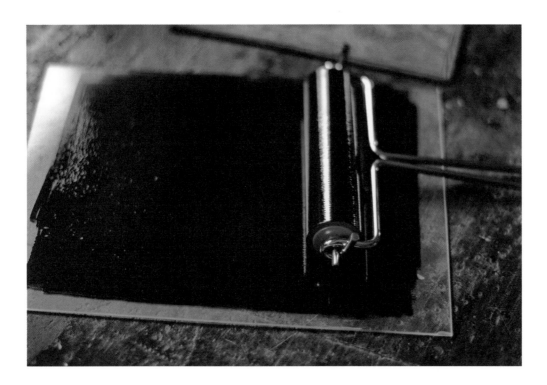

With the roller covered in ink from rolling it onto the glass, cover the linocut with ink. Apply the ink in a few layers, picking up ink from the glass as needed. Lay a piece of paper over the linocut for a test print, and use a spoon to evenly press the paper to the linoleum.

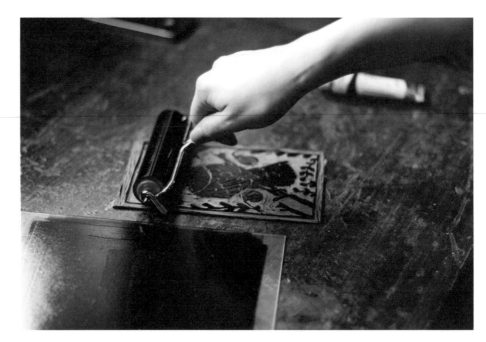

After making a test print, you can adjust the carving and amount of ink based on the results. You can decide if you want the characteristic linocut texture created by irregularities in the carving or if you'd rather keep the background completely white. If you want your print to be more precise and white, you may need to do more carving and remove all the areas in the background where ink is visible. On my linocut, you can see the little bits of black ink on the background.

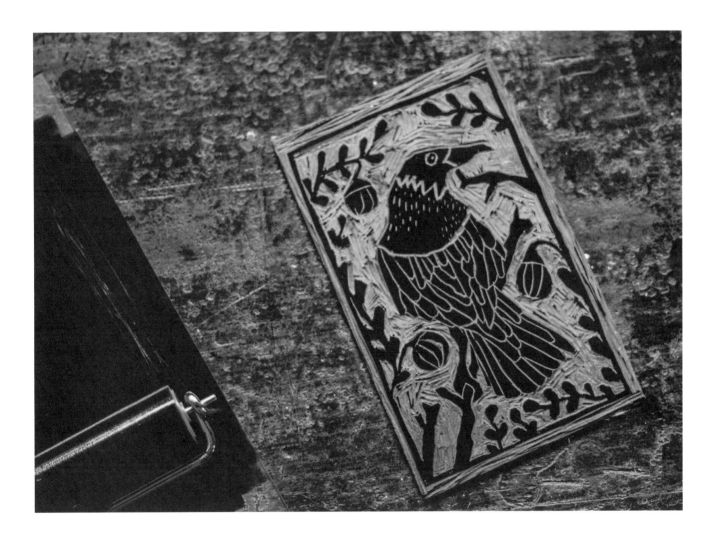

Results

Each print you make will be original and one of a kind, depending on the amount of ink used, pressure applied, texture, and style of carving. Here are some of my results. You can see where I used less ink and where I used more.

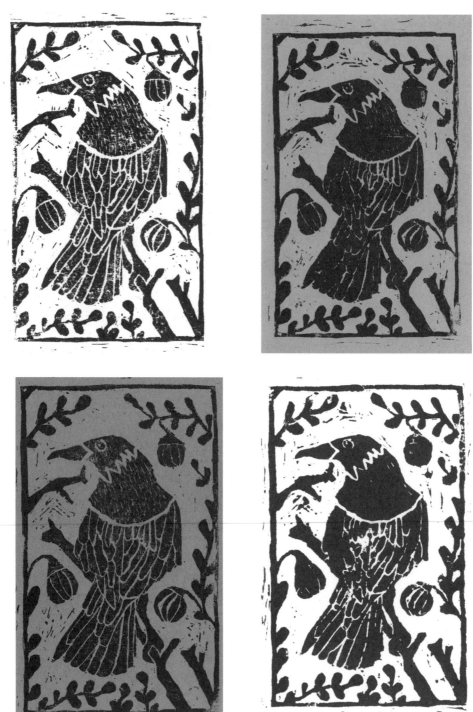

The white paper is a special kind of paper designed for printmaking, and the gray paper was originally in one of my sketchbooks—I chose it just because I liked the texture! You can see that you don't really need special paper for linocut printing—almost any paper will do. You can even experiment with using colorful papers.

Color Variations

Do you want to create a colorful print from one linocut? You need more inks, but it's possible. All you need to do is use masking tape to protect different areas of the linocut as you work!

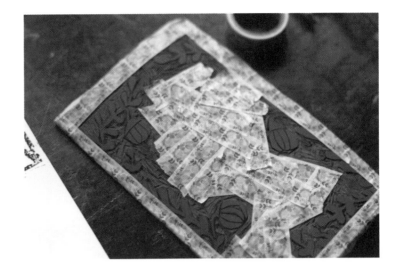

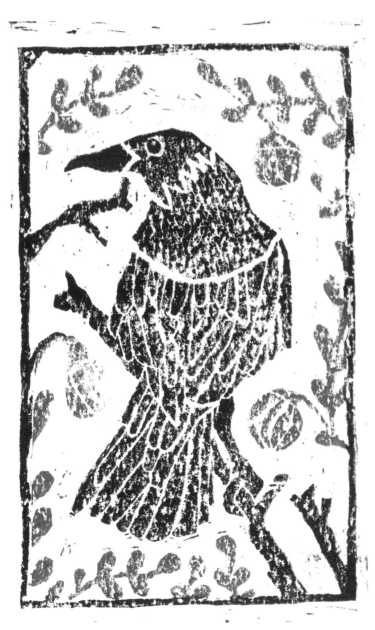

I wanted the plants in my print to be green, so I covered the bird with tape first. Then I applied green ink with a roller, and I carefully removed the tape before printing. After printing the plants, I covered them with tape so that I could ink the bird and border separately.

ARTIST'S TIP

Use a pencil to make tiny marks to help you place the linocut in exactly the same place!

105

CREATIVE EXERCISE: BIRDS IN FLIGHT

It might seem difficult to paint a bird in flight, but all it takes is a little practice! Sketching a bird silhouette is a good place to start, even if you want to create elaborate and complex illustrations. Each type of bird has its own unique silhouette and characteristic flying style.

Can you identify the birds shown here? See if you can match each bird: Sparrow, Eagle, Goose, Swan, Swallow, Owl, Dove, Hummingbird, Tern.

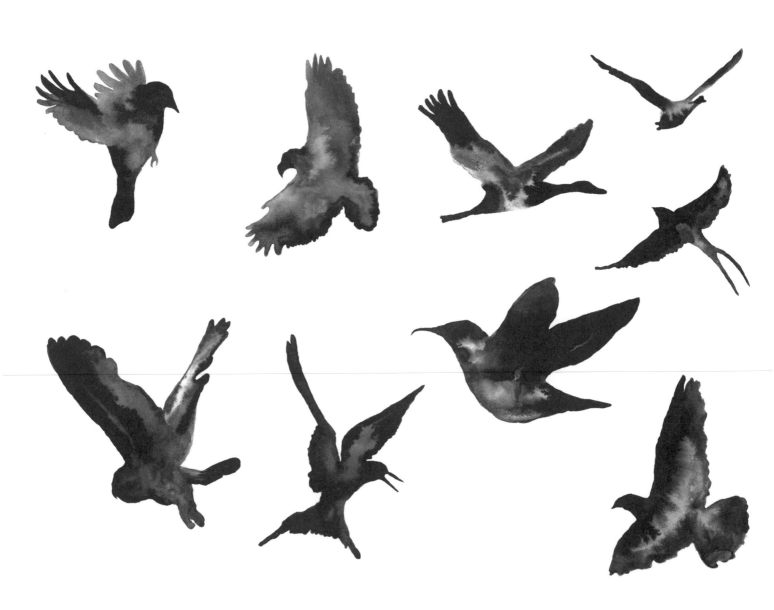

When I draw a bird or any other animal, I start with the silhouette. But how do I get this silhouette? Even though a bird's feathers may confuse our clear perception of its shape, try to reduce the bird to simple shapes that are easy to draw.

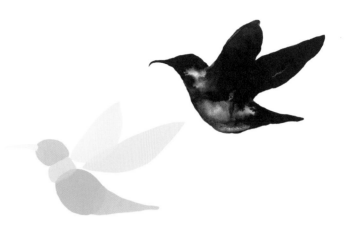

Your turn!

With a pencil, sketch the silhouettes of several birds in flight. It's OK to start with simple shapes and connect them later. You can do the outline with a drawing pen so that you can distinguish the shapes from the silhouette itself. Once you've drawn the outline, don't forget to add individual feathers and other details.

EXOTIC ANIMALS

It's so exciting to study unique wild animals from all around the world! They inspired me to connect this topic with a contemporary, surreal, hipster style of illustration. You can explore artistic tricks like creating animals from geometric shapes, mixing ink with other media, and, most importantly, installing animals in new and unexpected contexts. From animal metaphors and placing ink drawings over photos or newspaper to logolike illustrations created with a ruler, there's a lot to explore!

ELEPHANT

In this tutorial, we'll look at how to draw exciting combinations of human and animal qualities and create metaphors from different areas of life. This elephant is a robust lady working at the office and waiting for her lunch break. This aspect of the world isn't considered very interesting, adventurous, or romantic, but even this everyday part of many lives can be made interesting!

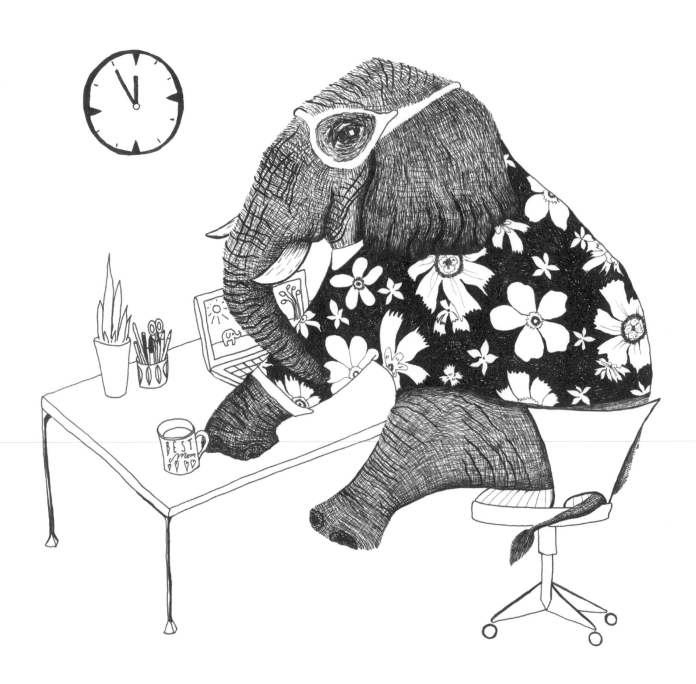

DEVELOPING THE CONCEPT

I spent some time studying elephants and created a few mostly realistic sketches to learn the shape of the animal first so that I could push it further and create something surreal. I learned that elephants sit, so I decided to use that to my advantage and create a sketch with the elephant sitting as it would in life.

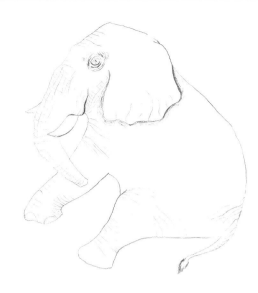

Sketching

Sketch the animal, and then add a desk with thin legs to contrast with the wide legs of the elephant. Sketch in other office objects, such as a notebook, a cup of coffee, plants, pens and pencils, and a clock that shows it's almost lunchtime.

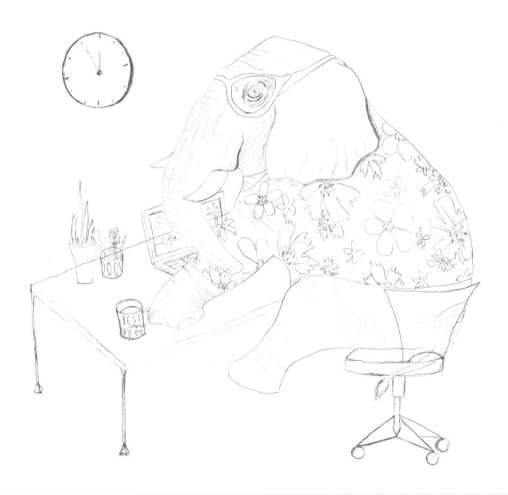

Materials	DRAWING PAPER	MANGA BRUSH PEN
	PENCIL	COLORED PENCILS
	THIN DRAWING PEN	

Inking

Elephant skin is full of wrinkles and shadows; draw
them lightly in pencil. Instead of tracing the outlines
of the elephant with ink, fill its shape with hatching.

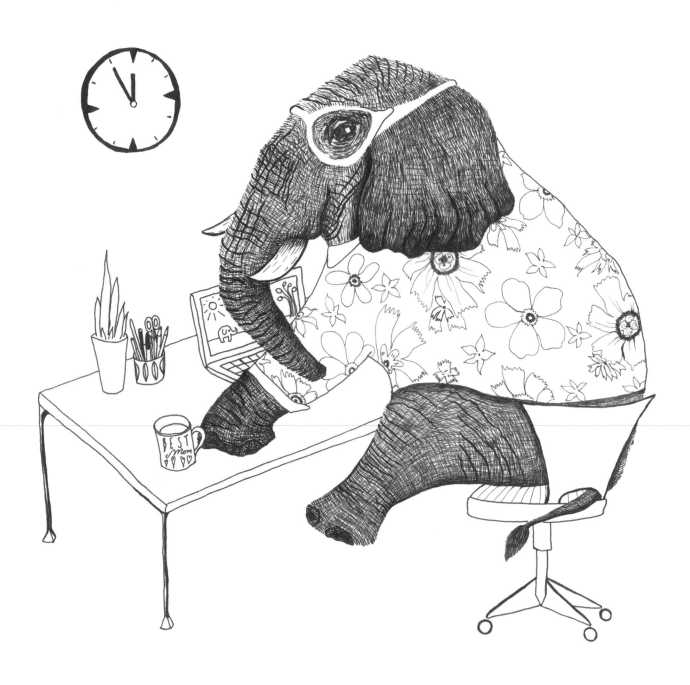

With a thin drawing pen, make short, quick strokes to create the underlying texture of the elephant's skin.

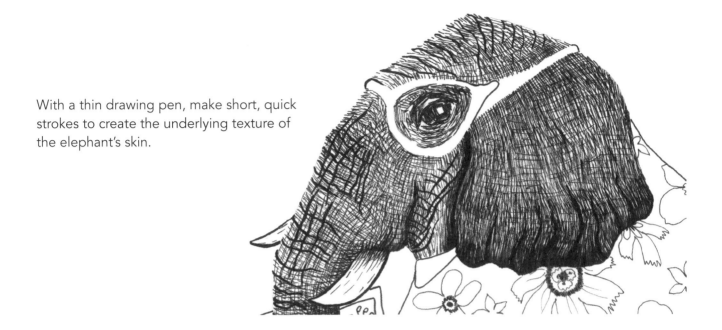

Crosshatching makes the surface look cracked. Draw the most prominent wrinkles with a flexible manga brush pen, using the strokes to create the impression of volume.

Ink the details of the office, but keep them simple and flat so that they don't draw attention from the elephant.

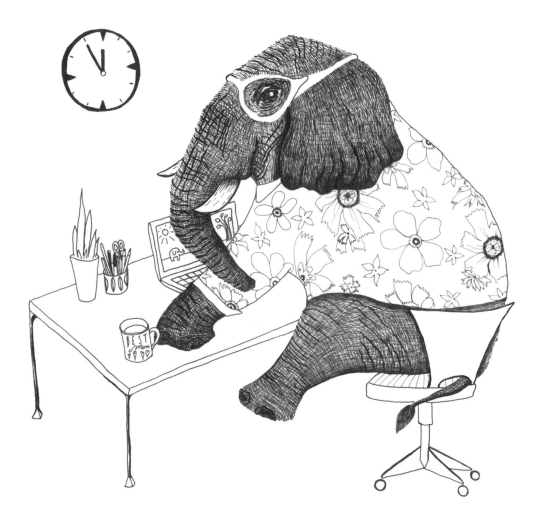

Trace the floral pattern with the thinnest drawing pen you have, and then fill in the dark areas of the blouse. I use a light pen and create very short lines, leaving small areas of the blouse blank.

Adding Color with Colored Pencils

Finish some details of the illustration with colored pencils or the medium of your choice. I select several matching colors and combine them to create an attractive pastel palette. Remember to start with the light colors and move to the darker shades.

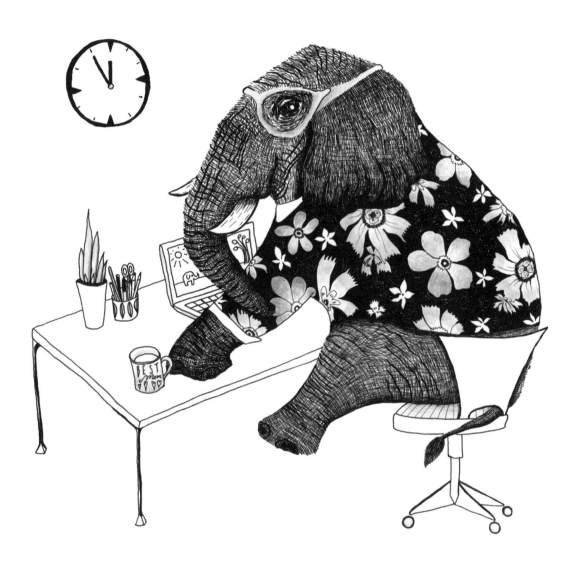

GIRAFFE

This moody illustration combines two popular illustration techniques:
drawing over text and color dripping.

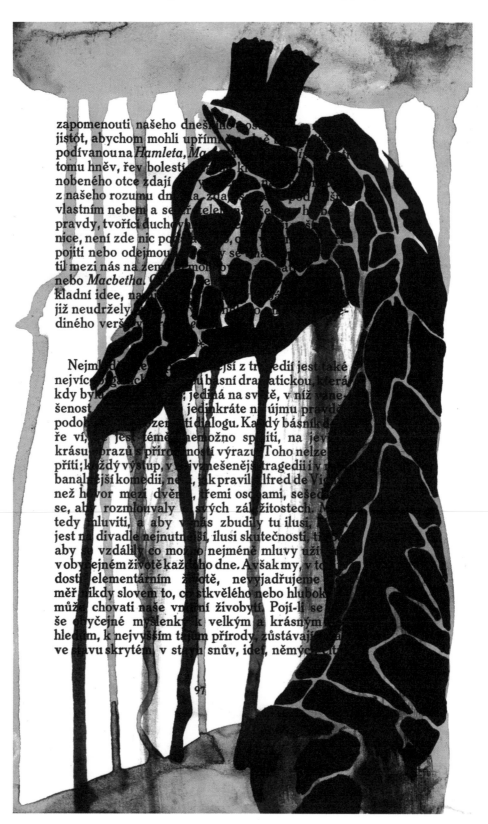

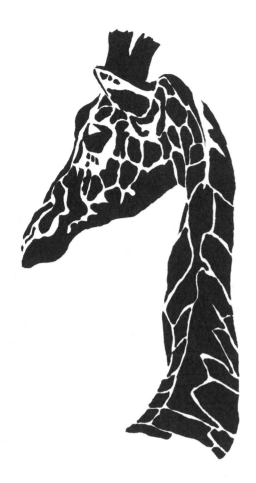

Preparation

Start with a light pencil sketch. In my sketch, I aim to reduce the giraffe to patches instead of using traditional outline.

Fill the sketch with black ink.

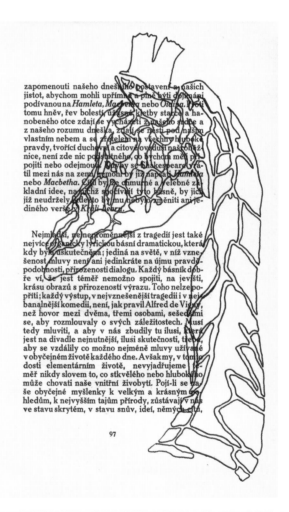

Use a light box or sunny window to trace the outlines of the patches onto a page from an old book or a yellowish sheet of watercolor paper.

Materials

OLD BOOK PAGE OR A YELLOWISH SHEET OF WATERCOLOR PAPER*

SKETCHING PAPER

PENCIL

BRUSH PEN OR PAINTBRUSH

INDIA INK

LIGHT BOX (OPTIONAL)

WATERCOLOR PAINTS (OPTIONAL)

*IF YOU PLAN TO ADD DRIPPING WATERCOLORS, PRINT THE TEXT OF YOUR CHOICE ONTO A SHEET OF YELLOWISH WATERCOLOR PAPER WITH A COMPUTER AND PRINTER.

Inking

Ink the design with a brush pen.

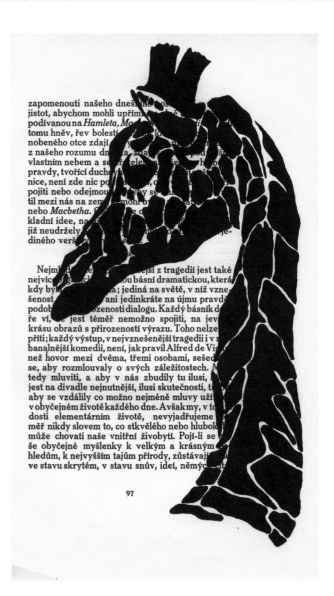

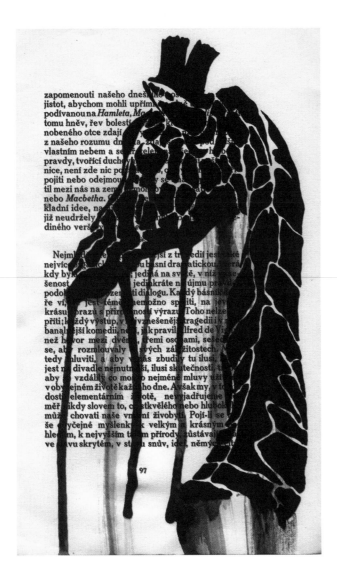

Dripping Ink

This is where things get messy! Apply drops of india ink and water on the lower parts of the giraffe's spots, and let it trickle down. I start with the eye to create the impression of a crying giraffe. I also use a paper towel to smudge the ink downward. The result depends on the weight of paper that you use.

Dripping Watercolors

If you're working on watercolor paper, you can add watercolor paints to finish your illustration. If you're using an old book page, you can also try this watercolor technique, but proceed carefully with a light application of water. Apply lines of watercolor paint at the top of the page, and then add water until the color is heavy and flows down like the ink. I also use watercolors to paint the rest of the giraffe's body.

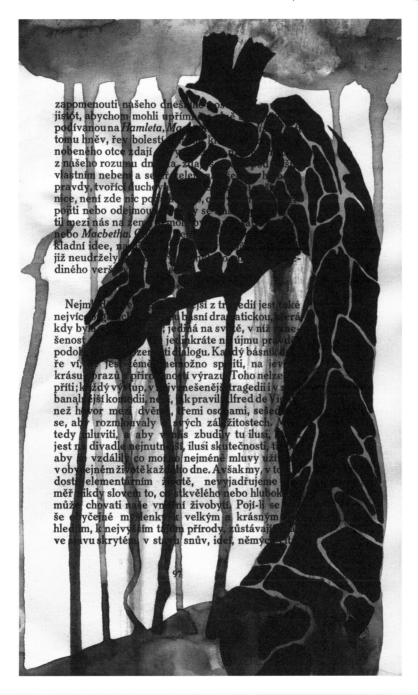

ARTIST'S TIP

Blowing into a straw to move the ink over a painting is my favorite way to create this effect. Need some more inspiration? How about a flying bird with dripping wings or a hedgehog with dripping spines?

Rhino

This whimsical illustration depicts pieces of land emerging from the rhino's back, creating a separate universe. World-bearing creatures are sometimes featured in ancient mythologies, typically as turtles or elephants.

This illustration is inspired by double-exposure photography, in which photographers create surreal imagery by combining two photographs to create something fresh and unexpected.

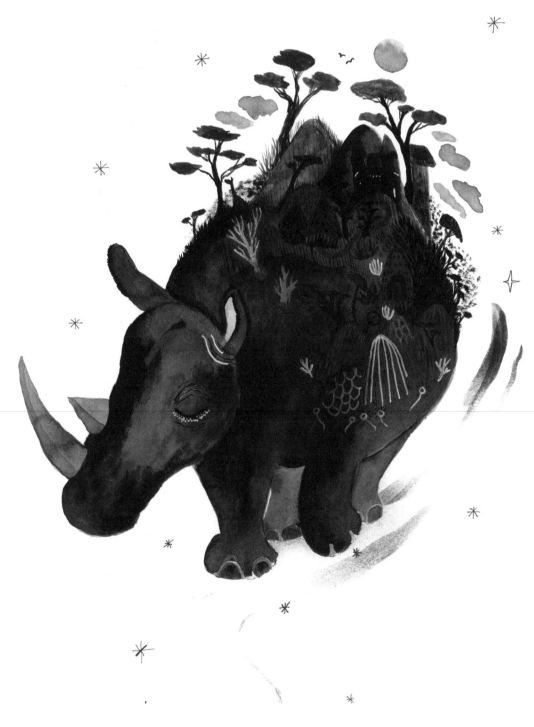

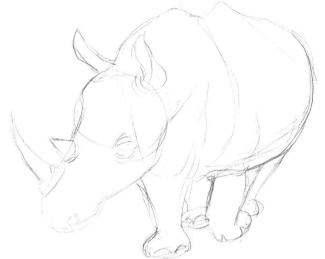

The Sketch

Start by studying the essential shapes and contours of a rhino's body. Use these shapes to create the outline of the sketch.

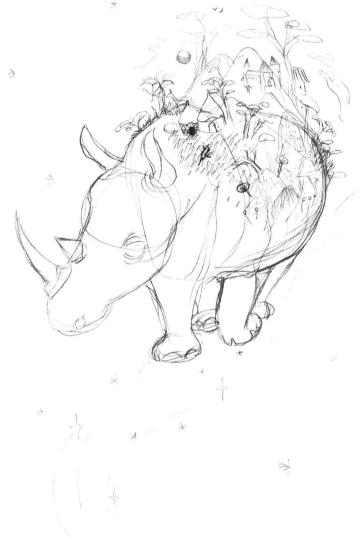

Now let your imagination go wild! Exaggerate the top of the rhino's back and draw mountains, trees, small homes, etc. I studied different kinds of African houses for my sketch. To depict the rhino running through a galaxy, I also add stars and lines to show movement.

Materials	INDIA INK	GOUACHE PAINT
	WATERCOLOR BRUSHES (NO. 2 AND 0)	WHITE GEL PEN
	BRISTOL PAPER & SKETCHING PAPER	LIGHT BOX (OPTIONAL)
	THIN DRAWING PEN	

Inking

Place the sketch on a light box, and put a new sheet of paper over it so you can paint without using pencil lines. If you don't have a light box, use a window and very lightly trace the lines. Dilute india ink, and use a watercolor paintbrush to fill the body of the rhino with a light layer of ink wash to create the silhouette of the animal.

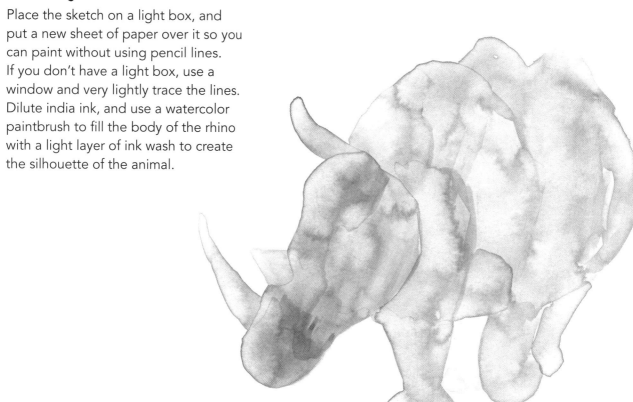

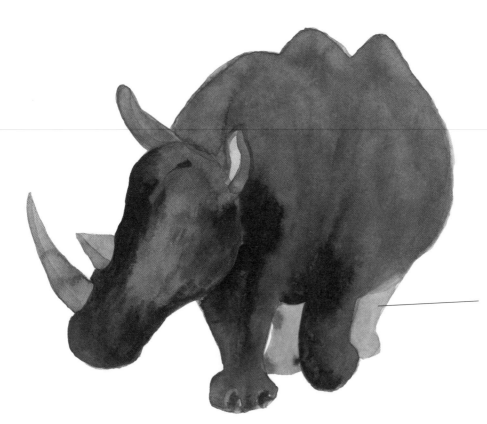

Next, apply a darker wash of india ink and create some shadows.

Leave the rear legs light gray to show that they're in the background.

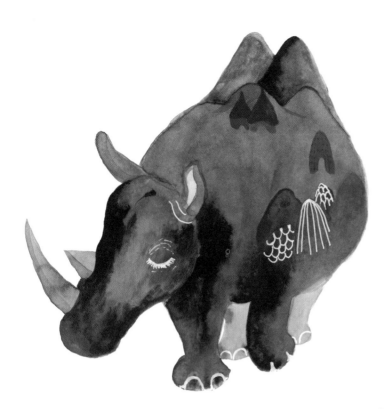

Gouache

Use gouache paint to begin painting the hills and houses on the rhino's back, and use a white gel pen to define some of the details, such as the eyelid, ear, and toenails.

Use a thin watercolor brush to draw the tree trunks and black details. For the stars and smallest details, use a thin, flexible liner pen in black. Paint the houses and tree leaves with gouache. Use ink to fill the moon, as well as the clouds and a few quick strokes for the path. Add details to the landscape until you're happy with the result.

CREATIVE EXERCISE: GEOMETRIC ANIMALS

A unique illustration technique is to break down animals into geometric shapes. In this exercise, we'll look at how it's done, and then you can try to create your own geometric illustrations!

Start with a very simple sketch of the animal of your choice, or use a photo of the animal's silhouette. Place the sketch on a light box and put a sheet of white paper over the design. Mark all the important points with a pencil. On this panda, you can see how I marked almost every spot where the angles change.

Use a ruler to connect the spots that make up the silhouette first. As you work, allow the ink to dry so you don't smudge the lines.

Create geometric shapes in the body by connecting the dots. I create mostly triangles, but you can draw any polygonal shapes you like! Connect the closest dots with one another. If a shape seems too large, simply add another dot in the middle. Use a thicker pen to trace the outline of the animal again for a more defined silhouette. Finish any black shapes with a white gel pen.

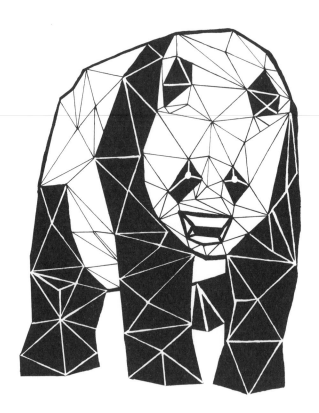

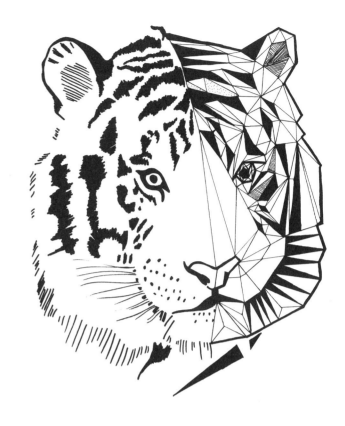

There are many variations on this technique. In this illustration, one half of the tiger is done traditionally and the other half is geometric.

Hatching and stippling in the shapes can make your animals look even more 3-D. In the koala bear and elephant, you can see how these techniques create dimension.

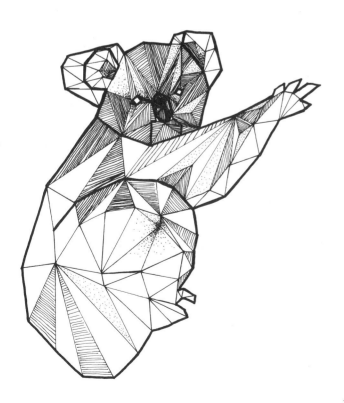

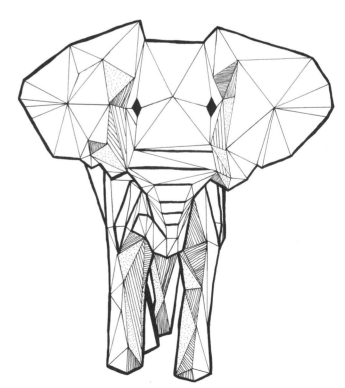

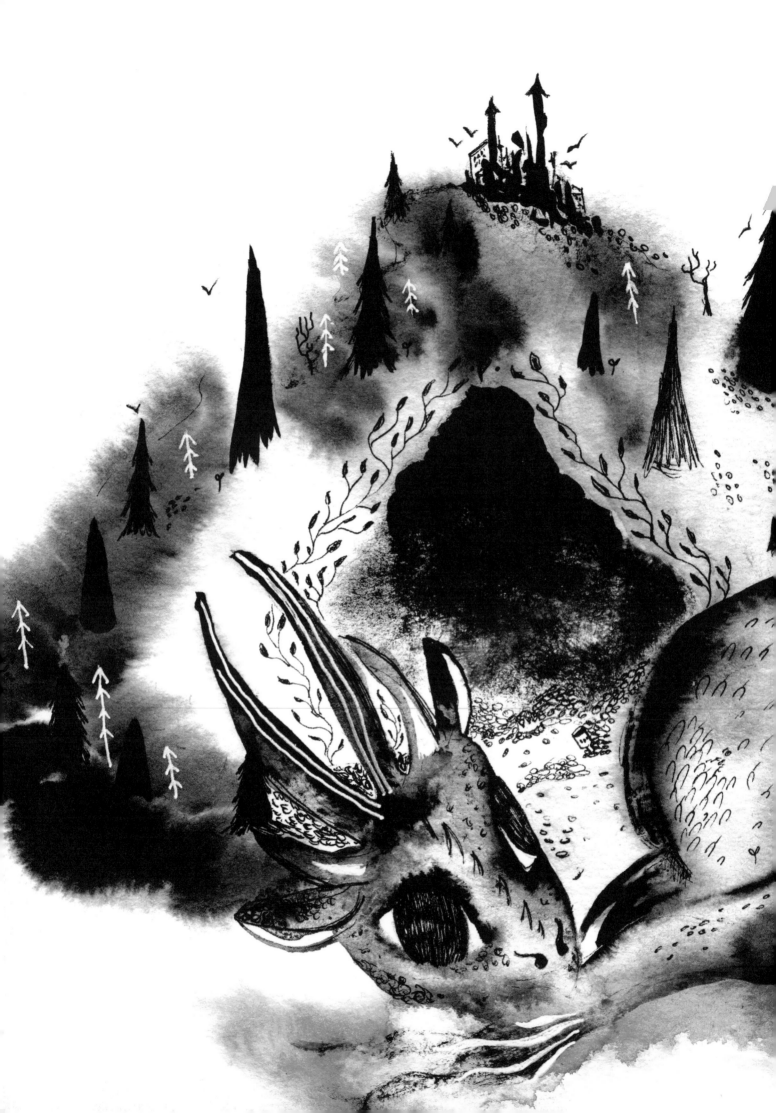

IMAGINARY CREATURES

Let's dive into fantastic realms full of creatures known from fairy tales. We will examine wet techniques along with traditional, precise inking, and work with watercolor washes for the background. You will have a chance to draw funny pictures without reference and create a brand-new creature of your own design. I'll also share tips on some simple twists that will make your illustrations unique and mind-blowing.

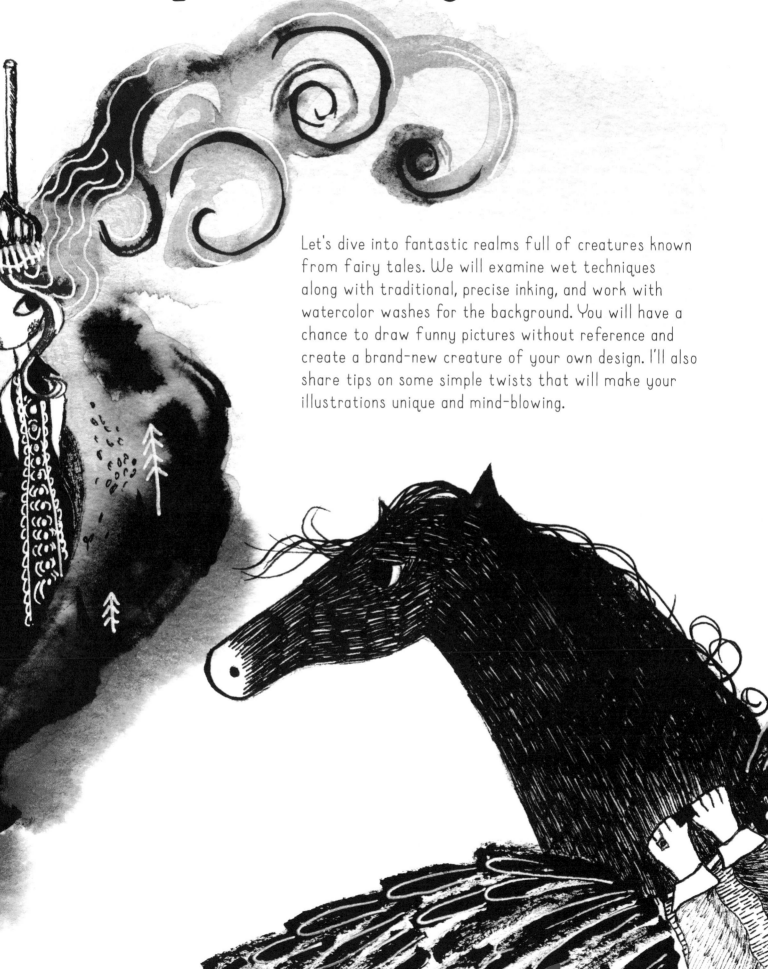

CREATIVE EXERCISE: MIX & MATCH ANIMAL PARTS

This fun exercise is all about creating an imaginary animal by combining body parts from different species. You'll need this skill throughout the chapter! There are many creatures of this sort from ancient mythologies (e.g., Greek hippogryphs, griffins, centaurs, gorgons, and harpies), as well as from newer folklore (e.g., jackalopes, the Jersey Devil, and other fearsome critters from American lumberjack folklore).

Maybe you've wondered how people invented such specific and strange combinations of features from various creatures. Now you can give it a try and experiment for yourself!

A great way to approach this exercise is to use the letters of your name for inspiration. Choose an animal that matches up with each letter to create your list of animals. Here is my example:

S	Swan
O	Octopus
V	Viper
A	Arctic fox

IF YOUR NAME IS VERY SHORT LIKE MINE, YOU CAN ALSO ADD THE FIRST LETTER OF YOUR SURNAME.

H ⟶ HORSE

I decided to use a swan for the wings and a gray horse for the torso and tail. The head is from an Arctic fox with a stylized mane. The legs are from an Arctic fox and scaled to fit the horse's body. The overall style of my painting is rather naïve, but you can also draw creatures that look realistic. I used india ink for the shading inside the body, a Japanese brush pen for the background, and white ink and a gel pen for the details.

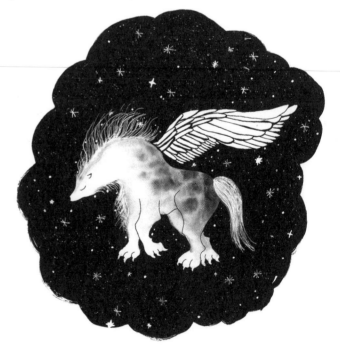

Practice Here!

Choose two to three animals from your list and draw your unique creation. If you feel brave, you can use all of them, but less is usually more in this case. Choose the animals you like or the ones you think would make for visually compelling results. Play with scaling and different animal parts.

Use the space here to work out some of your ideas.

USE THIS LIST OF ANIMALS IF YOU NEED IDEAS!

Arctic fox	Horse	Octopus	Viper
Bison	Iguana	Polar bear	Wolf
Crow	Jackal	Quail	X-ray fish
Deer	Komodo dragon	Rabbit	Yak
Eagle	Lion	Swan	Zebra
Frog	Magpie	Tiger	
Goat	Narwhal	Unicorn	

UNICORN

I prefer whimsical unicorns to classical white horses, and I never was a horse-drawing girl. When it comes to unicorns, you can take a traditional approach, but I prefer to have some fun with the process. This illustration is done by inking on a watercolor background. This kind of painting requires some planning before you start working with watercolors.

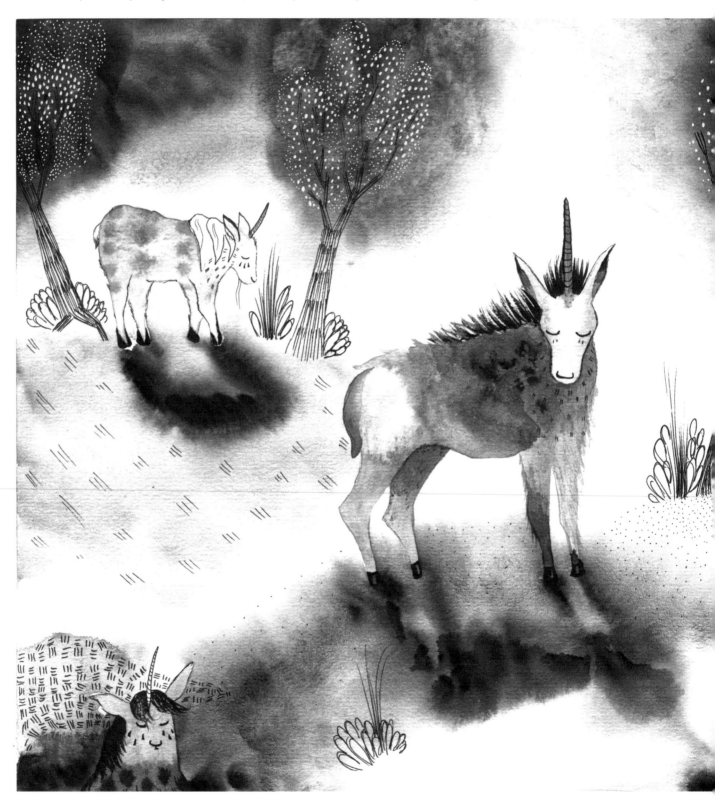

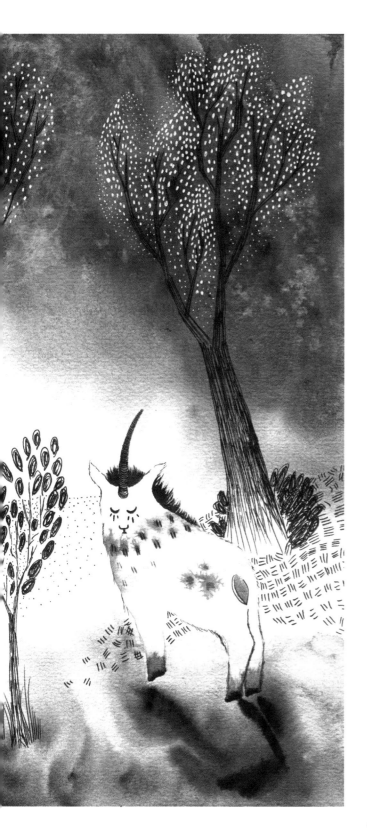

Materials

WATERCOLOR PAPER
PENCIL
MASKING FLUID
WATERCOLOR PAINTS
PAINTBRUSHES
PAPER TOWEL & SALT (OPTIONAL)
INDIA INK
DRAWING PEN
WHITE GEL PEN

Concept

Start by doodling unicorns. I wanted to create funny, odd, and cute unicorns, so I didn't use any references. Here's what I came up with!

I like some of my horse-unicorns, but I decide to experiment with the creature a bit more. How about developing unicorns from goats? In my research, I also discovered an animal called a "serow." There are several subspecies, and I found them so interesting that I simply had to use this creature as the base of my unicorns. The unicorns in the final illustration are also influenced by donkeys and zebras.

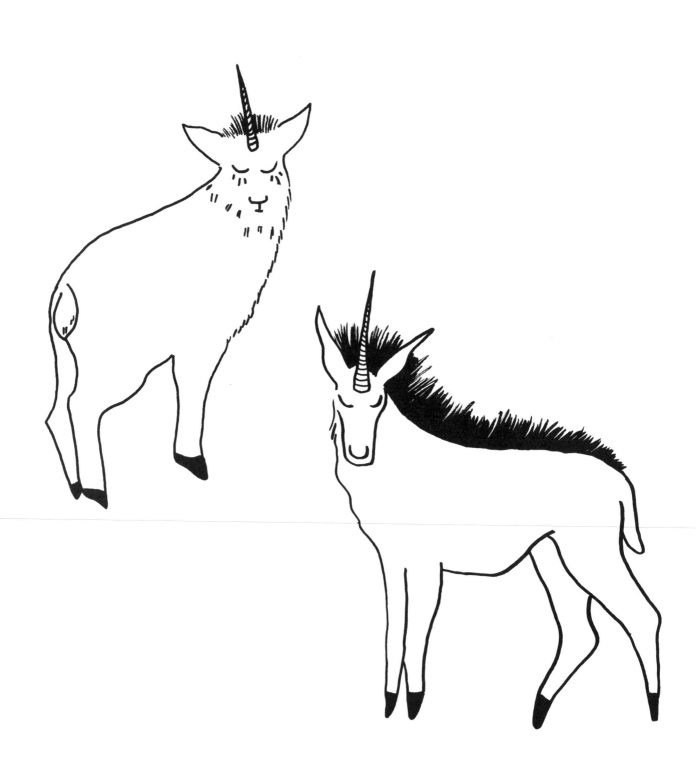

Watercolor Background

Start by making a light sketch of your unicorns on watercolor paper. Then, to ensure your unicorns remain white, use masking fluid to protect the sketches. Be sure to let the masking fluid dry thoroughly before applying any paint.

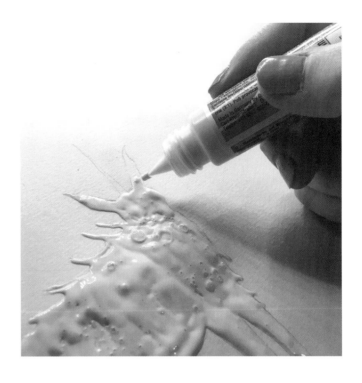

ARTIST'S TIP

This wet-into-wet painting technique is very similar to working with india ink washes. Once you apply the pigments, you follow the process of the color flowing over the paper.

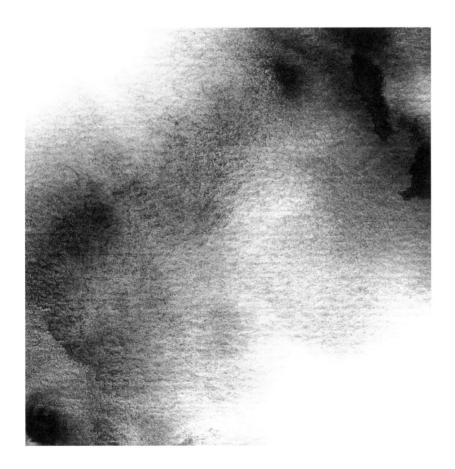

Cover the whole paper with water and start painting. I make short, quick strokes with my biggest mop brush using three colors: raw umber, neutral tint, and violet premixed from several colors.

If you like, add texture to the background using a paper towel and salt. Sprinkle salt over the paint while it's wet, and allow it to dry before brushing the salt from the paper. The salt will absorb some of the paint and water, creating a starry texture. With the paper towel, you can gently blot wet paint to pick up some of the color.

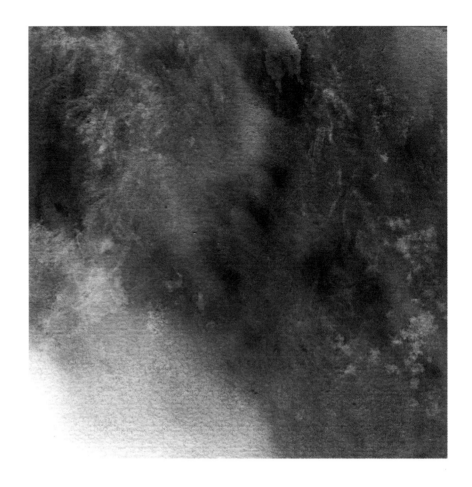

If you applied masking fluid over your sketches, allow the paint to dry before removing it. To remove, I like to start with a rubber eraser at one of the edges. Once I have the tip of the fluid pulled up, I can slowly and carefully peel it away. Pull the fluid up at an angle to avoid tearing the paper.

Inking

Next, ink in the unicorns. I chose wet ink washes, but inking with pens could be a great choice as well. I use a combination of ink washes made with a watercolor brush, the wet-into-wet technique, and drawing with a pen.

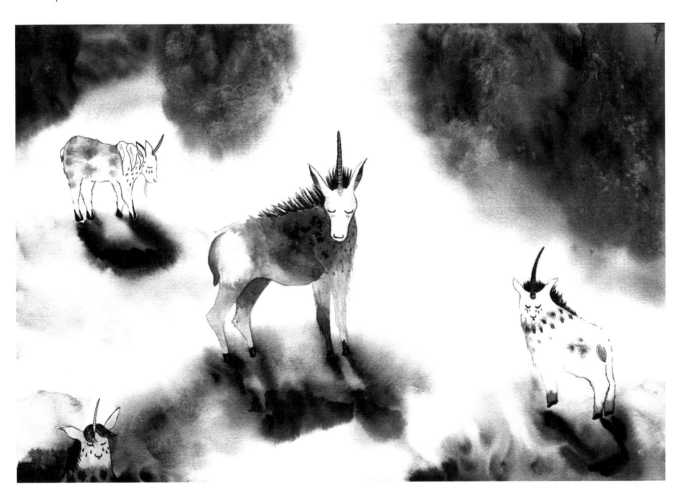

Did you know that many of the "unicorn horns" shown in cabinets of curiosities from the Middle Ages were actually narwhal tusks?

Digital Trick

Masking fluid can be tricky and sometimes creates unpredictable results. In this case, it repelled the water layer and left me with a few unintentional blank areas. I used Photoshop's clone tool to cover this imperfection digitally.

Before

After

Final Details

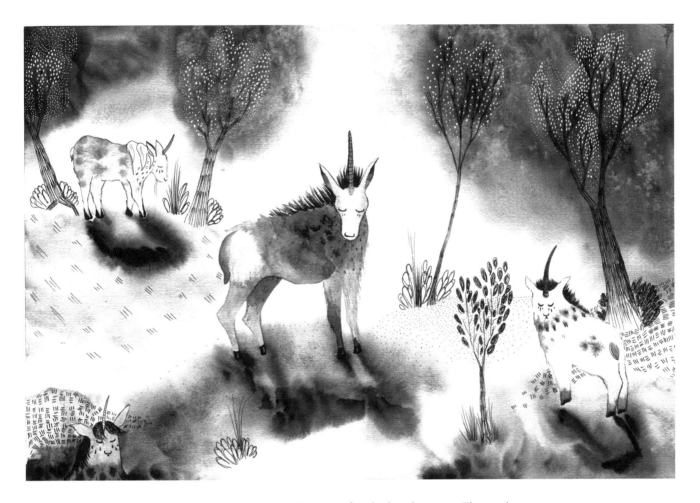

Use a drawing pen and a gel pen to finish the drawing. The violet parts of my background create the impression of a forest, so I complete them by adding trunks and tree crowns. I also add some texture throughout to enhance the landscape.

ARTIST'S TIP

Don't forget to visit www.quartoknows.com/page/inking-animals to download the bonus material for this book, which includes a step-by-step tutorial for inking a beautiful fairy-tale illustration of a dragon!

PHOENIX

This mythological bird is known for its cyclic regeneration from flames and ashes.
It's an optimistic symbol of resurrection. You'll find various descriptions that suggest
its similarity to peacocks, eagles, or herons. Silver flames surround my version of this
creature, which looks quite impressive on the dark background. What's even better is that
I created the whole effect with just one simple trick!

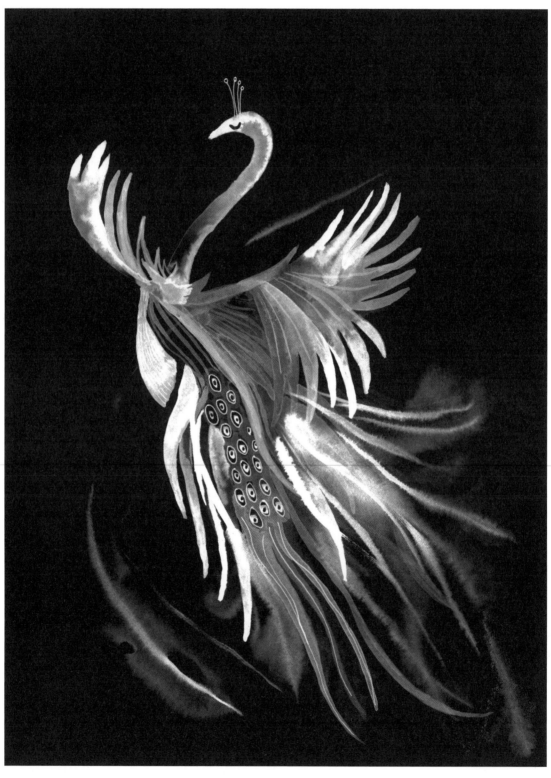

The Sketch

Start working out the silhouette of your bird. I begin with a stylized illustration of a peacock. If you're not sure where to start, you can revisit pages 106–107 and practice bird silhouettes.

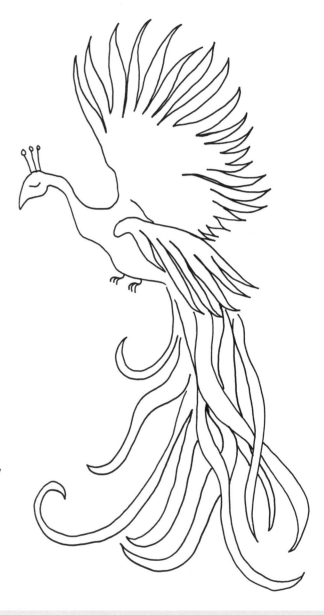

Then I redraw its feathers to look more like flames before moving my design onto my light box.

Materials

INDIA INK
BRISTOL PAPER
WHITE GEL PEN
DRAWING PEN (0.3 MM)

WATERCOLOR BRUSHES
LIGHT BOX (OPTIONAL)
GRAPHICS SOFTWARE

Inking

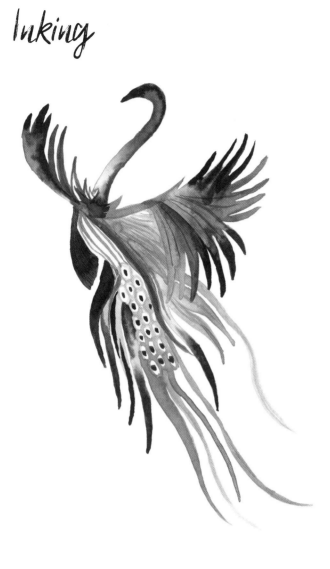

Place your final art paper on top of the sketch, and recreate it with a wet ink wash, part by part. If you don't have a light box, you can lightly trace your lines onto the final paper using a sunny yellow.

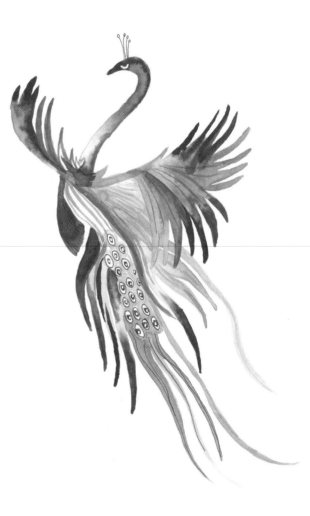

Add characteristic peacock feathers to the illustration and finish them with a white gel pen and a 0.3 mm drawing pen, as well as adding the eye and the crown with the gel pen.

To create a magical, messy, silvery look, cover the paper with a thin layer of water. Working quickly, because Bristol paper dries quickly, use quick brushstrokes to paint the flames and enhance the movement of the phoenix.

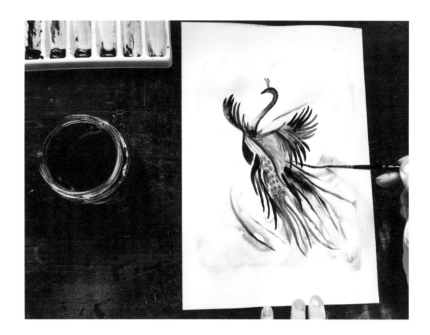

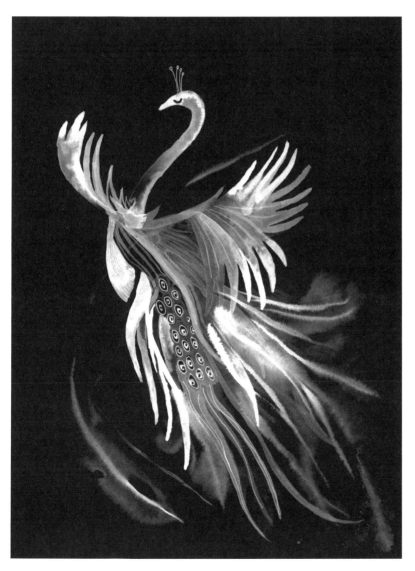

Digital Inversion

How does the magic happen? You may have already guessed by now. Scan and clean up the illustration in Photoshop or the photo-editing software of your choice, and invert the colors: Image > Adjustments > Invert (Shortcut: Ctrl/ Command + I).

ABOUT THE ARTIST

Sova Hůová is as an illustrator and art teacher. She started her creative career by teaching art classes and craft workshops for children. Working with children and their imaginations influenced her teaching style, which is therefore playful and helpful for overcoming creative blocks. Sova's first illustration projects were aimed toward children before she transitioned to teaching online art classes and freestyle watercolor workshops. She prefers traditional media, such as inks and watercolors, although she loves to experiment with new techniques as well.

Under the brand name Nesting Spirits, Sova creates whimsical artwork inspired by nature and influenced by her studies of ancient myths, folktales, and analytical psychology, which were her specializations during her university studies. Sova tries to awaken people by creating her own small world full of adventure, where reality meets the otherworld. She aims to encourage others to search for secrets in nature, see the magic of the life that we already have, and love the little things.

To learn more, visit *sovahuova.com*, or find her as *@nestingspirits* on Instagram.

Acknowledgments

I dedicate this book to all the creative people who don't feel "good enough" to make a career from their passion. I want to remind them that their boundaries are created mostly in their own minds. I hope this book will help and inspire them on their journey.

I want to thank my family members and friends for their support while I was working on this book, especially both my grandmas for helping with childcare. I'm also very grateful to my teachers for helping me in the best way they could, and I want to say thank you to all the people who believed in me before I trusted myself.